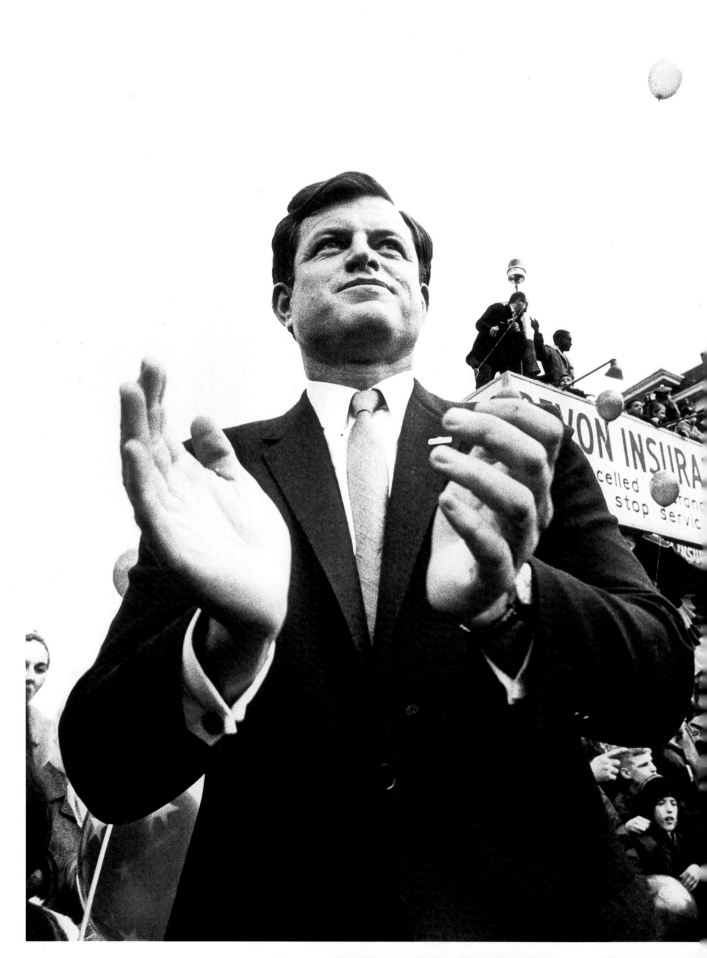

Ted Kennedy
Scenes from an Epic Life

By Award-Winning Photographers and Writers of *The Boston Globe*

Simon & Schuster
New York London Toronto Sydney

Simon & Schuster
1230 Avenue of Americas
New York, NY 10020

Copyright © 2009 by the Boston Globe

First Simon & Schuster hardcover edition March 2009

SIMON & SCHUSTER and colophon are registered
trademarks of Simon & Schuster, Inc.

For information about special discounts for bulk purchases,
please contact Simon & Schuster Special Sales at
1-800-456-6798 or business@simonandschuster.com.

Designed by Julian Peploe

Manufactured in the United States of America

10 9 8 7 6 5 4 3 2 1

Library of Congress Cataloging-in-Publication Data

Ted Kennedy : scenes from an epic life / by the photographers and writers of the Boston Globe
 p. cm.
1. Kennedy, Edward Moore, 1932– 2. Kennedy, Edward Moore, 1932—Pictorial works.
3. Legislators—United States—Bibliography. 4. United States. Congress. Senate—Biography.
I. Boston globe.
 E840.8.K35T425 2009
 973.92092—dc22 2008046870
[B]

ISBN-13: 978-1-4391-3806-9
ISBN-10: 1-4391-3806-0

Front cover Thirty-two-year-old Ted Kennedy campaigning for his first full term in the U.S. Senate along South Boston's St. Patrick's Day parade route on March 17, 1964. **Page ii** Four years later, leading the cheers along the parade route. **Back cover** The senator in his seventies, checking in at the Capitol, his home away from home for forty years.

BOOK STAFF
EDITORS: Janice Page, Thomas F. Mulvoy Jr.
ART DIRECTOR: C. Linda Dingler
WRITERS: Thomas F. Mulvoy Jr., Carol Beggy
RESEARCHERS: Liberty McHugh Pilsch, Bruce Pomerantz, Lisa Tuite, Richard Pennington, Richard J. Dill, Stephanie Schorow, Megan McKee, Leslie Sampson, Susan Vermazen
IMAGING: Ray Marsden, Jerry Melvin, Frank Bright, Liberty McHugh Pilsch, Bruce Pomerantz, Leslie Sampson, Dorian Color

Contents

Foreword by Senator John Kerry vi

Introduction by Martin F. Nolan 2

The Early Years: At Home with the Kennedys 5

The 1950s: From Harvard to the Altar 29

The 1960s: Birth and Death in Camelot 45

The 1970s: Down but Not Out 89

The 1980s: Unleashing the Liberal Lion 109

The 1990s: Uncle Ted Meets His Match 129

Twenty-first Century: The Lion in Winter 155

Fame, Friends, Photo Ops 183

Foreword

by Senator John Kerry

There's a revealing contradiction in this photographic project because the life, the liberalism, the love, and the loss—the story of Ted Kennedy—has never stopped at the frame's edge.

The Kennedy family will forever be associated with the words of Tennyson; but perhaps more than any other, it's Ted who gave new life to the old poet's line, "I am a part of all that I have met." No portrait of Ted Kennedy is complete without all those whose lives are forever enriched by his life's work—the sick, the poor, the elderly, the disabled—for whom, as the *Boston Globe* once declared, "in actual, measurable impact on the lives of tens of millions of working families . . . Ted belongs in the same sentence with Franklin Roosevelt."

And there's something unmistakably genuine, beautifully private, wholly *authentic*—that word overused in American politics but thoroughly Ted in every way—in the fact that this giant touched so many of those lives when the cameras were nowhere to be found. There are countless stories of friends who, facing a grim diagnosis, found Ted Kennedy personally working the phones to doctors across the globe on their behalf; of political adversaries and ideological opposites who benefited from Ted's compassion, men like George Wallace, who found Ted Kennedy intimately involved in his rehabilitation from a paralyzing gunshot wound; and the folks Ted met along the way—the child in a wheelchair whose hand Ted held for a long while in the hall of the Russell Senate Office Building on his way to a vote; the old man from Leominster, Massachusetts, oxygen tank by his bedside, whom Ted stopped to sit with in the hospital time after time; and, yes, the straggly haired, angry Vietnam vets facing possible arrest and political threats from the Nixon administration, whom Ted visited in April 1971, while other prominent politicians stayed away.

To appreciate fully the greatness of Senator Ted Kennedy is to understand that behind each snapshot, there has always been a heroic steadfastness. Behind the liberal lion who roared—gloriously—"the dream shall never die" is a lifetime spent in tireless service to the creed that "circumstances may change, but the work of compassion must continue." Day after day, decade after decade, Ted Kennedy has lived and legislated according to this creed, amassing a record of groundbreaking legislation equal to that of any United States senator in 232 years of American history.

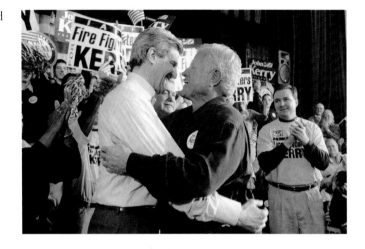

Campaign workers: Senator John Kerry has Ted's support at a rally in Iowa during his 2004 presidential run.

Behind each flash photograph of Ted smiling, surrounded by dignitaries, heads of state, fellow politicians, brothers and sisters, cousins and nephews, there are countless stories of dear and faithful friendship. On Inauguration Day 2005, it was Teddy and Vicki who arrived first at my family's home in Washington and lightened a day we'd all hoped might have been different. Each photograph of a warm embrace is testament to a friend who was always there by our side when the sun wasn't shining, but who seemed always —for our benefit—to have the sunlight in his face, that beaming smile and unmistakable baritone. Among his not-so-secret weapons have always been great humility, good humor, and a genuine affection for friends and strangers alike. His brother Robert once said that "all great questions must be raised by great voices." Ted's singing notwithstanding, the cause of American idealism knows no greater voice than that of this youngest Kennedy brother.

These photos capture his journey from the youngest of nine children to the patriarch and custodian of American liberalism and also our nation's journey from the "new frontier" to "new hope" to "the audacity of hope." It is the long, impressive, and enduring story of a great American life.

John F. Kerry has represented Massachusetts in the U.S. Senate since 1985 and was the Democratic nominee for president in 2004. A high school volunteer for Kennedy's first Senate race in 1962, Kerry became reacquainted with Senator Kennedy in 1971 as a Vietnam veteran testifying against the war before the Senate Foreign Relations Committee. In January 2009, Kerry became the committee's chairman.

Introduction

By Martin F. Nolan

At the movies, Americans watched *Lawrence of Arabia* and *To Kill a Mockingbird*; the Boston Celtics won their fourth straight championship; Rachel Carson wrote about a new concern, pollution, in *Silent Spring*. And in 1962, Edward Moore Kennedy was elected to the United States Senate, where he has served longer and, in the opinion of many historians, more effectively than most.

Damon and Pythias, Castor and Pollux. Mythical heroes often come in pairs. But in America, ever since John Francis Fitzgerald went to Congress in 1895, the public has been fascinated by a vast tribe of Kennedys. They remain at center stage in the twenty-first century. In a saga mixing Greek tragedy and soap opera, press coverage has often been dominated by sycophants or haters. During the Ted Kennedy decades, the *Boston Globe* took neither side—not out of virtue but because posturing is unnecessary. This man is news, in season and out.

In 1965, when he tried to win a federal judgeship for a friend of his father's, the *Globe* documented the nominee's sketchy legal career. Many in the Senate and in the Johnson administration had their doubts, but Kennedy persisted. So did the *Globe*. After he withdrew the nomination, the senator was unhappy with his hometown paper.

Bob Healy, the editor who led the investigation, defined a reporter's code: "If you tag a guy, be sure to show up that day to hear about his beefs." So Healy, fellow reporter Jim Doyle, and I went to Kennedy's office, entering through a staff door, as we normally did. Instead of legislative assistants, we were confronted by the senator, surrounded by aides, all fuming and growling. One of them wordlessly removed his PT-109 tie clasp—the badge of Kennedy loyalty—and hurled it. I caught this souvenir and still have it. In 1966, the judgeship stories won the *Globe* its first Pulitzer Prize. Kennedy congratulated members of the prize-winning team, saying, "You couldn't have done it without me!"

In good times or bad, in Massachusetts, Washington, or at numerous Jefferson-Jackson Day dinners over the last fifty years, the *Globe*'s reporters, photographers, and editors have chronicled Ted Kennedy's odyssey. Those of us long on the congressional beat had this advice for newcomers: BYOV,

or bring your own verbs. The eloquent orator as interviewee is concise and cryptic enough to make characters in a Robert B. Parker novel sound garrulous.

But the Ted Kennedy story is compelling because of a work ethic as focused and varied as any the U.S. Senate has ever seen. His influence on international policy reaches from Vietnam to Northern Ireland to refugee camps in forgotten places. In domestic policy, the roster includes just about any issue you could think of, including civil rights, schools, jobs, housing, and immigration. In 1980, he described his ideals to the Democratic National Convention: "Our commitment has been, since the days of Andrew Jackson, to all those he called 'the humble members of society—the farmers, mechanics, and laborers.' "

Legacy is a word the senator never uses and rarely thinks of—not as often as he thinks about, say, getting low-cost housing built. Seniority, the Senate's yardstick of power, also fails to excite him. Over the decades I interviewed him as he reached milestones as one of the twenty or ten or five longest-serving senators. "Really?" was all he'd say before changing the subject.

The presidential ambitions that defined his brothers ended well before his failed 1980 White House bid. Since then, he has, as he said, "taken up the fallen standard" of Jack and Bobby, both icons of cool. The youngest is different, a beacon of warmth, his politics less cerebral and more deeply emotional. The citizens of Massachusetts share this personal bond, notable for its length and depth. In nine Novembers since 1962, he has averaged 65 percent of the Bay State's vote. "I am a part of all that I have met," he said of his odyssey, quoting his brothers' favorite poem, Tennyson's *Ulysses*:

Made weak by time and fate, but strong in will

To strive, to seek, to find, and not yield.

Martin F. Nolan worked at the Boston Globe *from 1961 until 2001 as a reporter, columnist, Washington Bureau chief, and editor of the paper's editorial pages.*

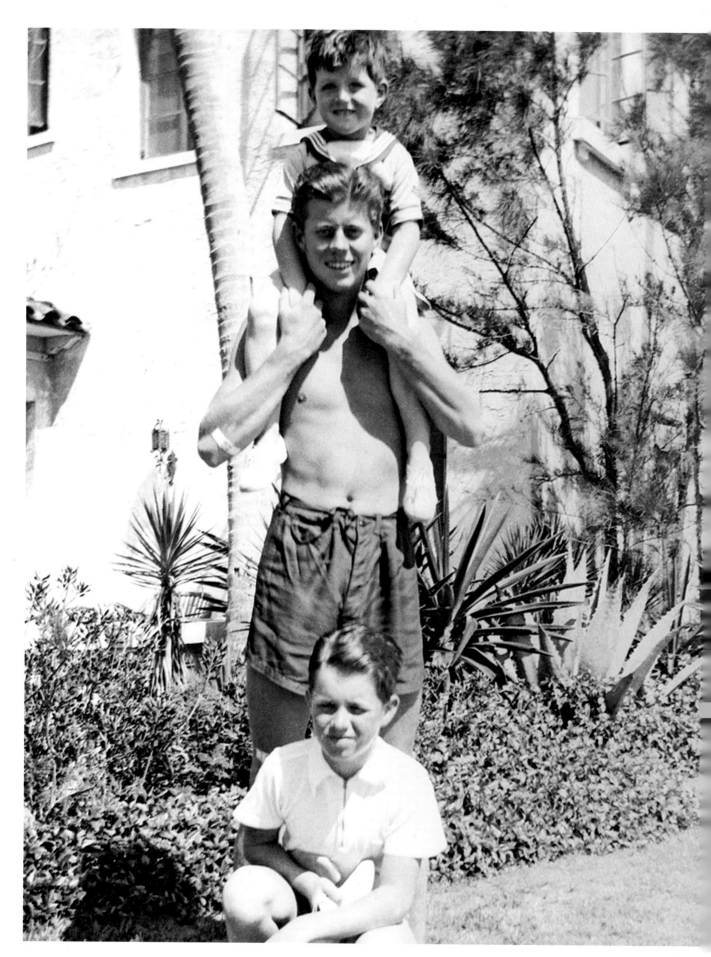

I am reminded of our awesome responsibility each time I gaze from the windows of my office in Boston. I can see the Golden Stairs from Boston Harbor where all eight of my great-grandparents set foot on this great land for the first time. They walked up to Boston's Immigration Hall on their way to a better life for themselves and their families.

—Senator Edward M. Kennedy on the floor of the U.S. Senate on May 21, 2007, during a debate on immigration reform legislation

The Early Years
At Home with the Kennedys

Fun at Palm Beach, 1936. Jack shoulders Teddy as Bobby crouches below.

In 1886, Patrick Joseph "P. J." Kennedy, a successful saloonkeeper and

investor in banks and real estate, was elected a state representative out of Ward Two in East Boston.

In November 1894, John Francis "Honey Fitz" Fitzgerald, fourth oldest in a family of twelve children,

was elected to the U.S. House of Representatives for the first of his three terms in that body.

Over the following two decades, both men, children of parents who had left a starving Ireland

in the mid-1800s, lived true to form: "P. J." kept his own counsel as ward boss in East Boston while

continuing to sit in the Legislature, and the garrulous and flamboyant "Honey Fitz" came home to

Boston from Washington to run for the mayor's chair, which he won twice.

But it was with their children that the two men made their biggest marks on history: on October

17, 1914, Rose Elizabeth Fitzgerald and Joseph Patrick Kennedy were married. The scene at

Cardinal William O'Connell's private chapel was the first chapter in a remarkable American story.

Joe Kennedy, a Boston Latin School and Harvard College graduate, was a quick study and a

dynamo, in person and across an office desk. His work ethic and instinct for profit-making stood

him in good stead as he moved quickly in the years after his marriage to find stability and security

for his offspring—five girls and four boys, the last and cheeriest of whom was Edward Moore "Ted"

Kennedy, born in 1932. Between 1914 and the year of Ted's birth, Father Joe earned millions,

finding excitement and profit in such wide-ranging endeavors as banking, shipping, real estate,

moviemaking, the stock market, brokerages, liquor, and government. And when the stock market

crashed in late 1929, Joe Kennedy was one of the few who prospered and moved beyond the carnage.

After serving for fourteen months as Franklin D. Roosevelt's first chairman of the new Securities

and Exchange Commission, Kennedy was nominated by FDR to one of diplomacy's most glamorous

positions: U.S. ambassador to Great Britain.

As the photogenic Kennedy clan, with adorable young Teddy commanding more than his share of the spotlight, began to gather in London for the introduction of the new ambassador to the king and queen, Adolf Hitler was moving aggressively all over Europe. Kennedy spoke with foreboding about the immediate future, and soon many in Britain and the United States were criticizing him for what they saw as his defeatist posture. War came in September 1939. A year later, Kennedy sailed back home to resume life in New York, Palm Beach, and Hyannis Port, now persona non grata with the Roosevelt administration for his strident isolationist views.

The resilient British proved the ambassador wrong about their imminent demise, and after Pearl Harbor, his sons Joe and Jack and, later, Bobby, directly joined the fight against the Axis powers. One made the ultimate sacrifice—Lieutenant Joe Jr., a naval aviator with twenty-five combat missions over Europe to his account, died in August 1944 during an operational flight.

Joe Jr. had been his father's hope for a Kennedy to get to the White House. Jack was next. After the war, nursing a heroic reputation and chronic back injuries, he took up the family standard and set his first ever campaign sights pretty high: the Eleventh Congressional District seat in Massachusetts. In the first of many subsequent productions, all Kennedy hands moved on deck to work on the campaign, and their candidate won easily.

For the youngest Kennedy, just seventeen years old when the 1940s closed out, life up to then had been one big drama: several years abroad meeting kings and queens, prime ministers, and a pope; the next five years at home cheering three brothers at war and mourning the loss of one; and the thrill of playing bit roles in the election of his brother Jack to Congress. But college was ahead, and his life would pick up the pace quickly as the 1950s dawned.

Irish-American Roots

The story of the Kennedys and the Fitzgeralds of Boston, two families whose union by marriage early in the twentieth century produced a president of the United States, a U.S. attorney general, and three U.S. senators, has its modern roots in Ireland in the mid-nineteenth century, a land then being laid waste by a devastating failure of the island's mainstay potato crop and a resulting famine, known as the Great Hunger.

In 1848, Patrick Kennedy bid good-bye to his relatives and neighbors in the village of New Ross in County Wexford and set out for America, where he married Bridget Murphy, also from Wexford, and moved into a home in East Boston, a short distance across the harbor from the city proper. Six years later, Thomas Fitzgerald left behind his village in County Limerick and sailed across the Atlantic to Boston, where he married Rosanna Cox, from County Cavan, and settled in the city's immigrant-rich North End. Boston was not a hospitable place for immigrants, especially Irish Catholics, during the years when Patrick and Bridget and Thomas and Rosanna were trying to make a living for their large families. The descendants of the founding Puritans controlled the city in every aspect. They were mostly cold to newcomers and had a special antipathy toward the Irish. But the Kennedys and Fitzgeralds persevered, working hard for little money to create lives for themselves along the margins of city life while waiting for a chance to move into the mainstream of civic activity.

It didn't take too long. Within thirty years, Kennedy and Fitzgerald men were key players in the hurly-burly of Boston's political arena.

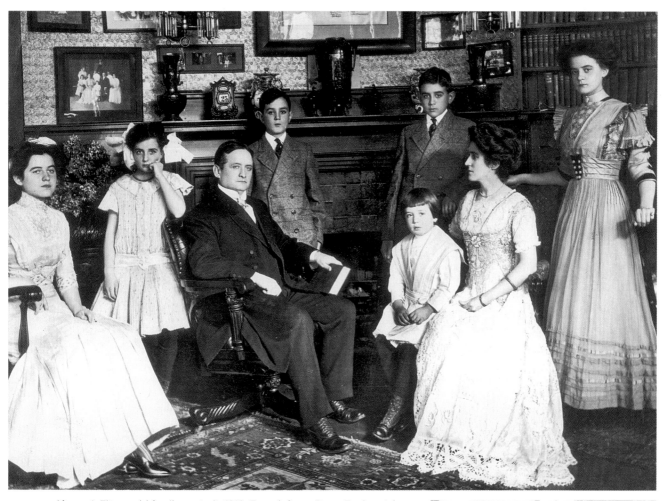

Above A Fitzgerald family portrait, 1910. From left are Rose, Eunice, John F. "Honey Fitz," John F. Jr., Thomas, Frederick (seated), Mary Josephine (Hannon), and Mary Agnes. **Right** Patrick Joseph "P. J." Kennedy and his wife, Mary Augusta (Hickey), center, outside their home in East Boston (date unknown) with two of his sisters.

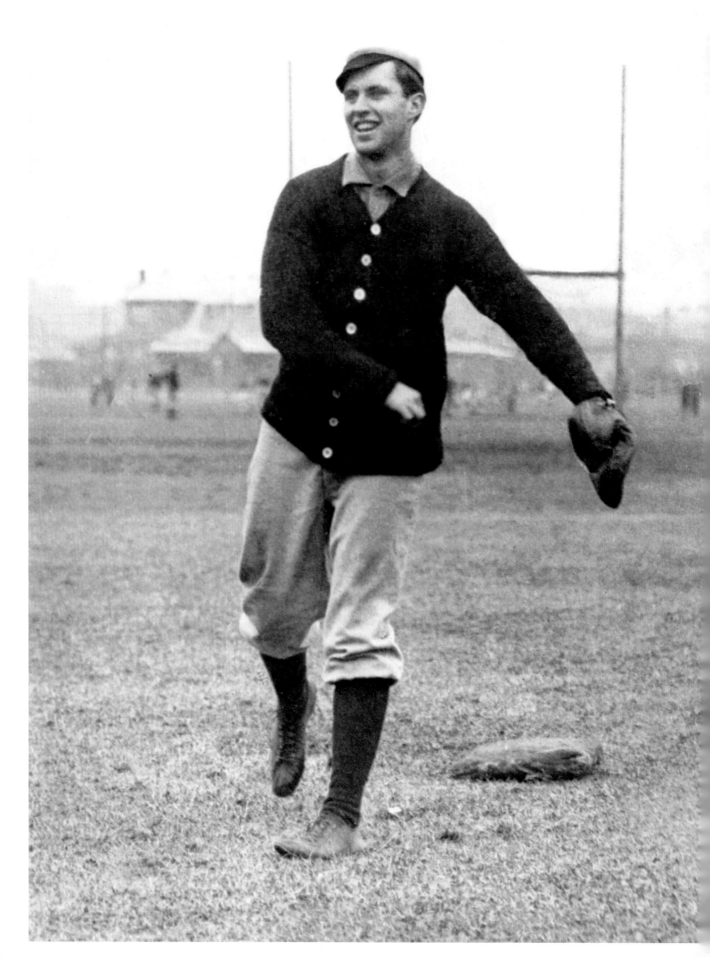

Opposite Joe Kennedy playing on the fields of Harvard. A baseball letterman at the college, he graduated in 1912.

Right (Top) Rose Fitzgerald, in a snappy pose aboard a cruise ship during a school year abroad. (Bottom) The Kennedys and Fitzgeralds gather at Old Orchard Beach in Maine, where Rose and Joe became friendly while the families vacationed together. "P. J." is second from left, Rose is on his right, next to her dad, "Honey Fitz," and Joe is second from right.

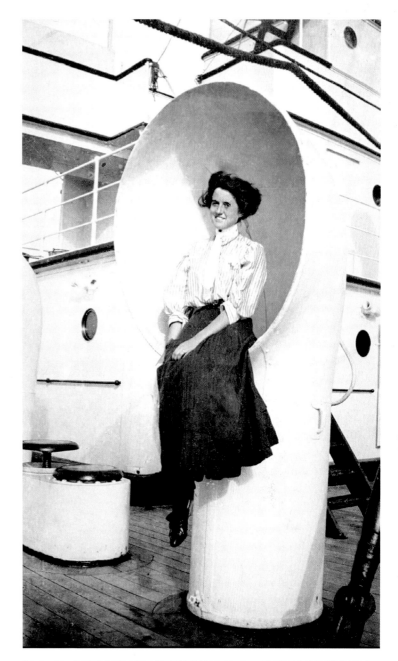

Joe and Rose Start a Family

The marriage of the hard-driving son of "P. J." Kennedy to the attractive daughter of "Honey Fitz" was a social event of high order in 1914 Boston. The ceremony and reception began the saga of an engaging family life beyond the provincial capital of the Puritans; while Rose was tending to their growing family in nearby Brookline and then in New York, Joe was making his way—and many millions—in the world of business and finance in Boston, New York, Hollywood, and places in between.

New Kennedys arrived in a steady stream. The first was Joe Jr., in 1915, then Jack (1917), Rosemary (1918), Kathleen (1920), Eunice (1921), Patricia (1924), Robert (1925), Jean Ann (1928), and, making it nine in all, Edward, in 1932. While Joe's success allowed Rose to employ help in running a busy household and to have a life beyond the front door, she still made time to admonish her children about their grammar, social lives, and general behavior. Joe and Rose believed in tough love—sometimes to the point of derision—but this was by all accounts a close, if competitive and complicated, brood.

Rose and her first five children in 1921. From left, Joe Jr., Jack,
Rosemary (seated), Kathleen, and Eunice.

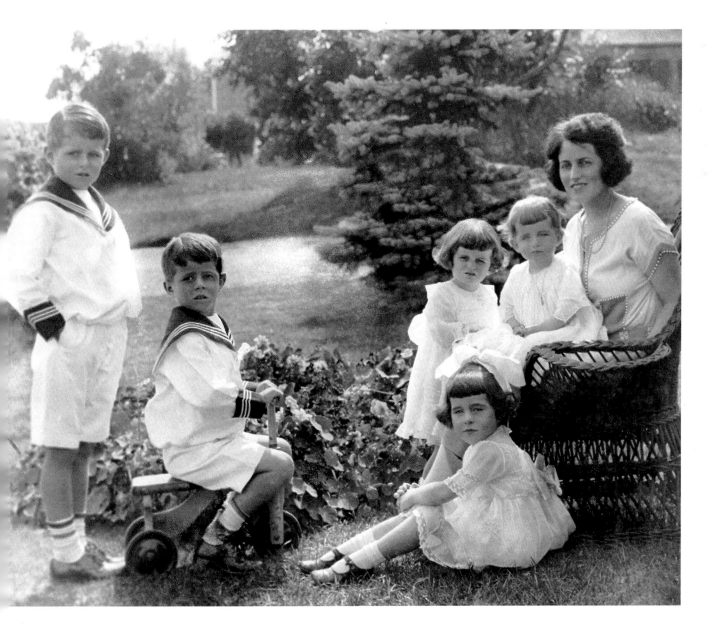

Teddy Makes the Scene

From the day he was born, February 22, 1932, Edward M. Kennedy was news.

The birth announcement that ran in his hometown newspaper gave the infant's weight as nine pounds, and it also included a report that grandfather "Honey Fitz" was "so jubilant he announced that he hoped the baby would be named George Washington Kennedy." Grandpa did not get his wish. Even though the chubby baby had the luck, or audacity, to be born on Washington's birthday, he would be known from the get-go as Teddy.

Because the Kennedys were never ones to let family life pass unrecorded by word or picture or both, we can easily revisit the days when Teddy played a starring role. Photographs show him on the beach at Hyannis Port, at play in Bronxville, taking in the London sights, and in a Palm Beach boxing ring. There is joie de vivre in his siblings' interactions with him, and clear affection even in their teasing.

In her magisterial volume *The Fitzgeralds and the Kennedys*, Doris Kearns Goodwin tells of the special relationship between the oldest and youngest boys: "Remembering a trip to the Cape one weekend, a friend recalled: 'The minute we got out of the car, Teddy came running up. Joe grabbed him and kissed him like a father would and hoisted him up to his shoulder. They were like father and son. When, after much lobbying with his father, young Joe got his first boat, he named it the *Teddy*.' "

But life was not all play. The youngest son would be brought up in the Kennedy manner: a proper, mostly private-school education through high school, including several semesters at "public" schools in England when his father was ambassador to that country, a posting that required occasional full-family attendances at meetings with the king and queen, prime ministers, and the pope.

(Left) Palm Beach, 1934: Eunice gets set to give Teddy a ride.
(Right) Bronxville, 1933: Young Ted takes up stroller duty.

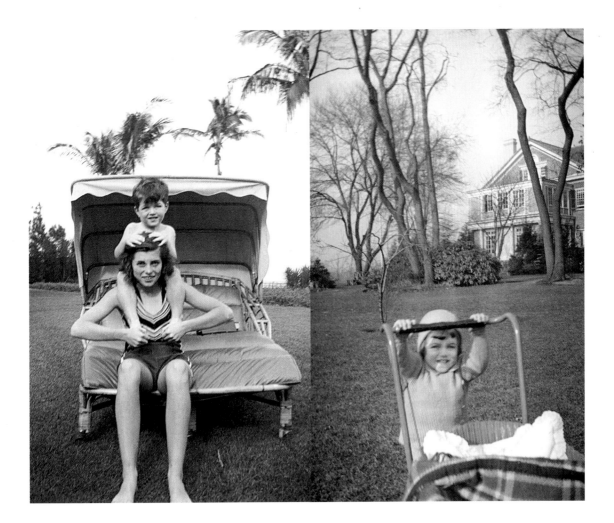

When the family returned from Europe, Joe Kennedy took permanent leave of public life, if not of

public influence. From then on, it would be up to his boys, especially Joe Jr., to carry on the family's

causes in the public arena.

15

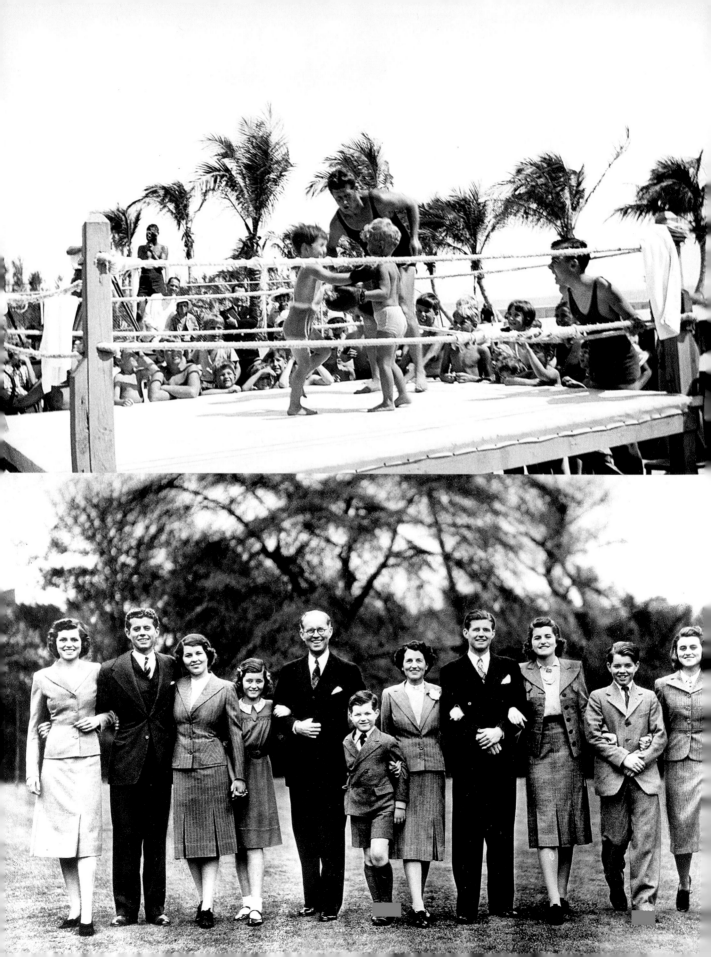

Opposite (Top) Ready for the bell at Palm Beach, 1935: Teddy squares off with his opponent. (Bottom) The Kennedys in full smile at the U.S. ambassador's residence in London, 1938. From left, Eunice, Jack, Rosemary, Jean, Papa Joe, Teddy, Mama Rose, Joe Jr., Patricia, Bobby, and Kathleen.

Below While his father meets with King George VI at Buckingham Place, an alert and curious Teddy waits outside with his box camera (and sister Jean) at the changing of the guard.

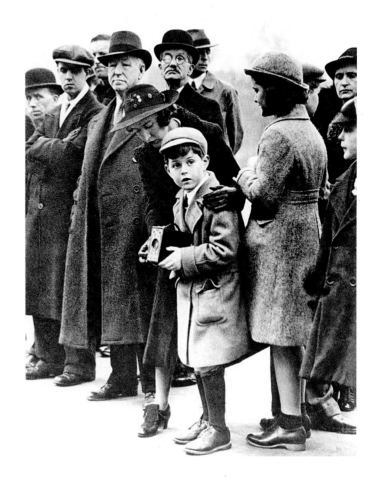

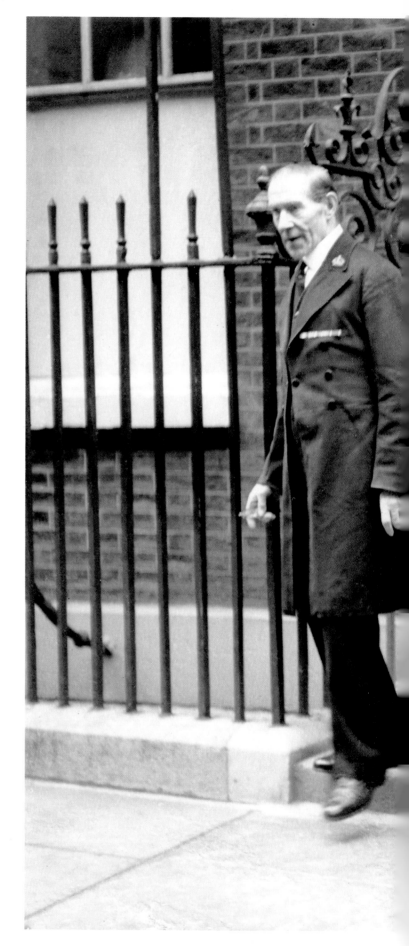

18 New Year's Day, 1939: Ambassador Kennedy
and Winston Churchill, two men with widely
disparate views of what the future held for
Europe, pose for the cameras on Downing
Street in London.

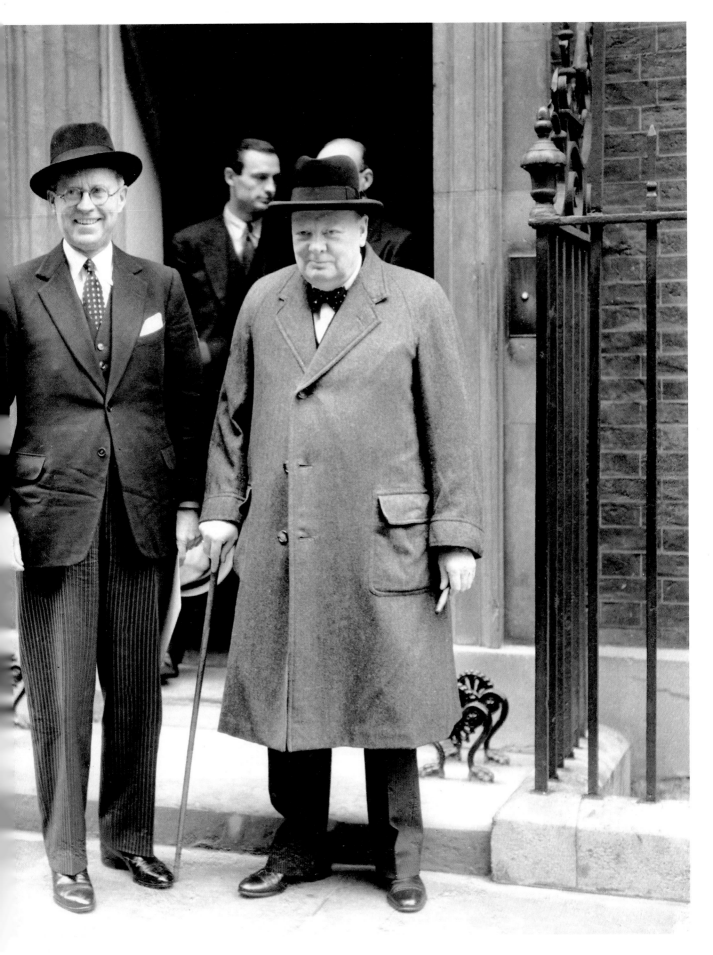

Where there were boats, there were always Kennedys at play. **Below** A New Year's Day outing in 1940. Clockwise from the back of the boat: Bobby, Joe Jr., Pat, Eunice, Jean, Rose, and Teddy. **Opposite** (Top) Teddy dips his toy boat into the water's edge in this 1938 photo. (Bottom) Ted, left, and Jack tighten things up after a sail on the *Victura* at Hyannis Port in 1946.

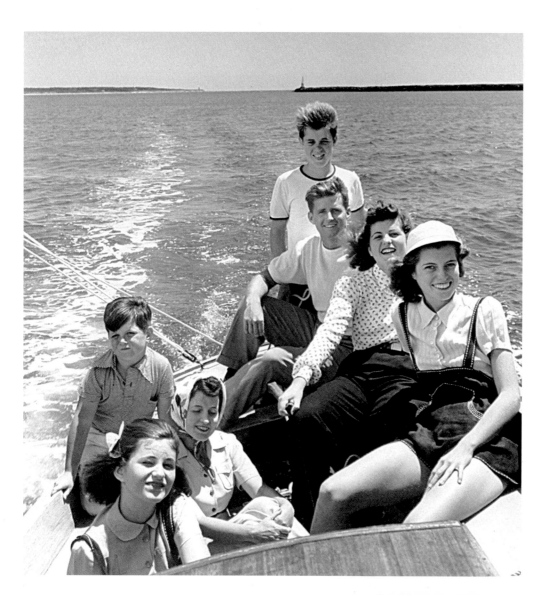

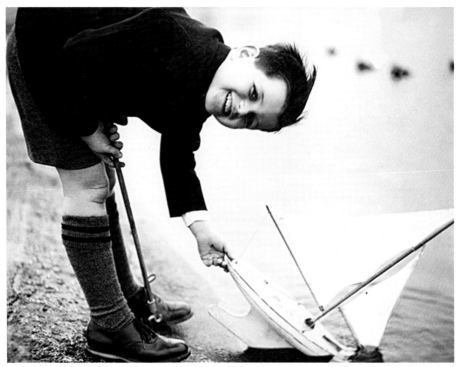

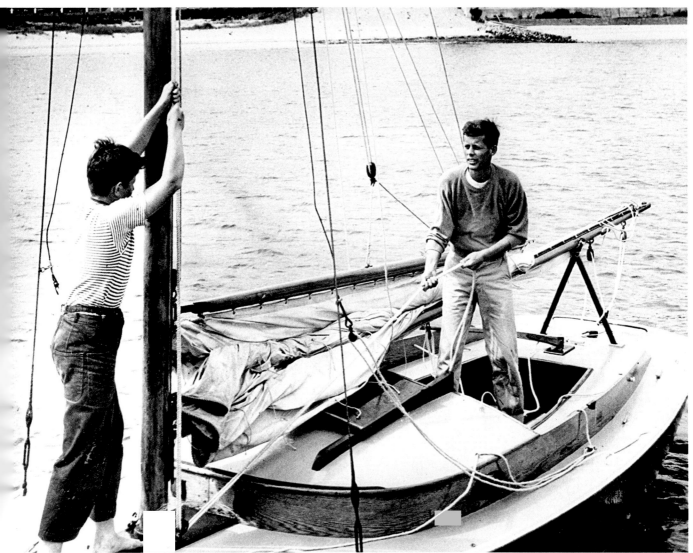

Tragedy Strikes

Joseph Kennedy's hopes for his oldest child anticipated a career in high public service, maybe even

the White House. But fate intervened: in the first instance of a child of Joe and Rose Kennedy dying in

service to the country, Joe Jr., a lieutenant-pilot in the Navy, was killed in the last year of the war when

his plane exploded over the English countryside. A year earlier, Jack's PT boat had been rammed by a

Japanese destroyer in the South Pacific. He had barely escaped death or capture while engineering the

rescue of the ship's crew, and in 1944 he underwent near-fatal back surgery for his injuries.

As the family was dealing with Joe's death and Jack's close call in combat, a third Kennedy child

was undergoing a sadly brutal life-changing experience. Rosemary, said to be mildly retarded, was

increasingly agitated, even violent, as she grew out of adolescence. Her father, accepting the medical

opinion of the time that her personality could be tempered by a prefrontal lobotomy, gave his consent

for the operation, which proved to be a failure; she was left mentally and physically incapacitated.

This once docile daughter was sent to live out her life in an institution.

After the war ended, Jack decided to make politics his vocation, and in 1946, with the dedicated

help of every relative equipped to campaign, he won a seat in Congress representing sections of

Boston and Cambridge and the city of Somerville. His success buoyed the family, but fate would

not let go of the Kennedys; in May 1948, Kathleen, the twenty-eight-year-old widow of a prominent

member of English royalty, died in a plane crash in France.

For Teddy the high school boy, all this brought tears that tempered the joys of growing up, but soon

it would be time for him to plot his own future.

Jack and Joe Kennedy show their pride as officers in
the U.S. Navy.

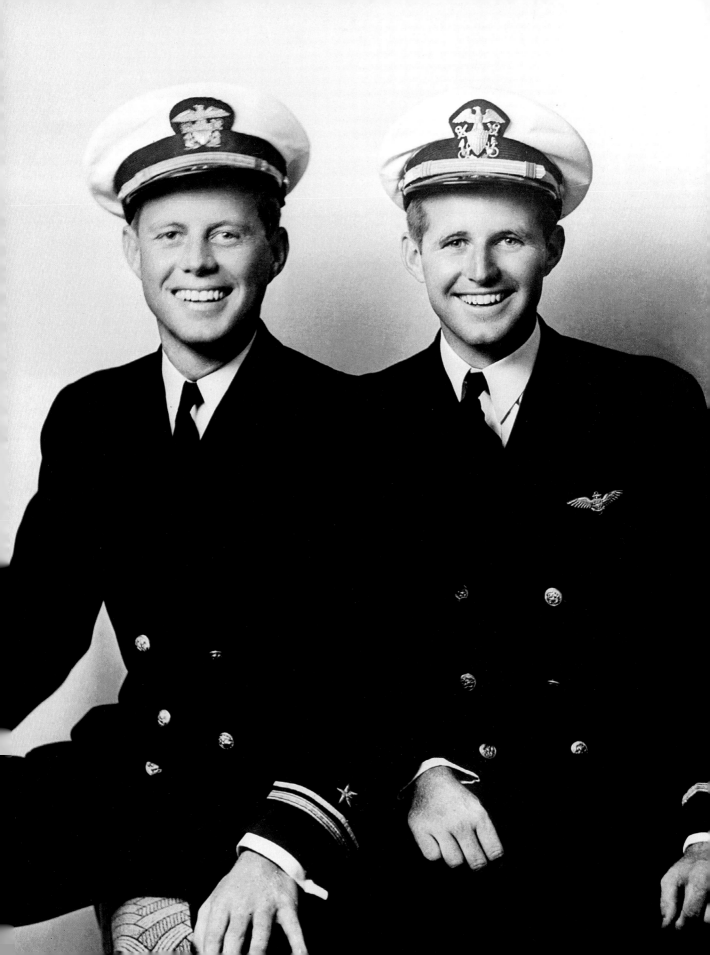

Below Big brother Joe and a gap-toothed Teddy in the spring of 1939.

Opposite (Left) Kathleen Kennedy pitched in on the war effort by signing up for duty with the Red Cross. (Right) Joe Kennedy with his flight training instructor, J. S. Dodge, in July 1941.

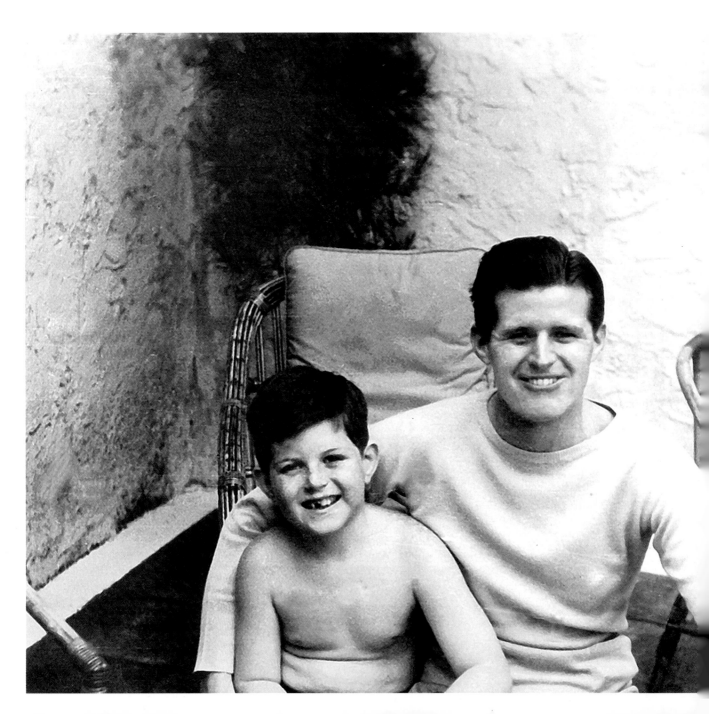

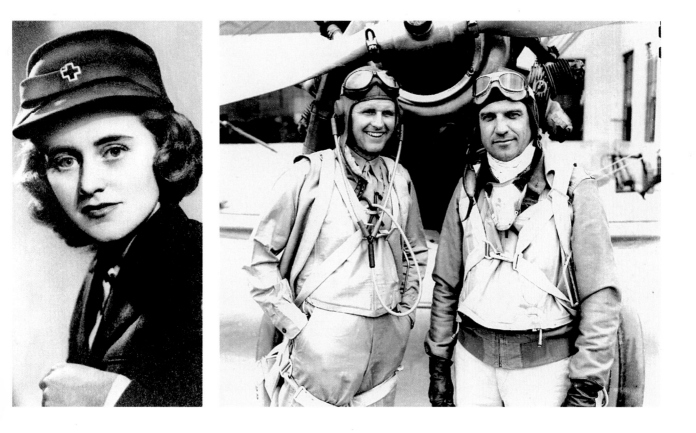

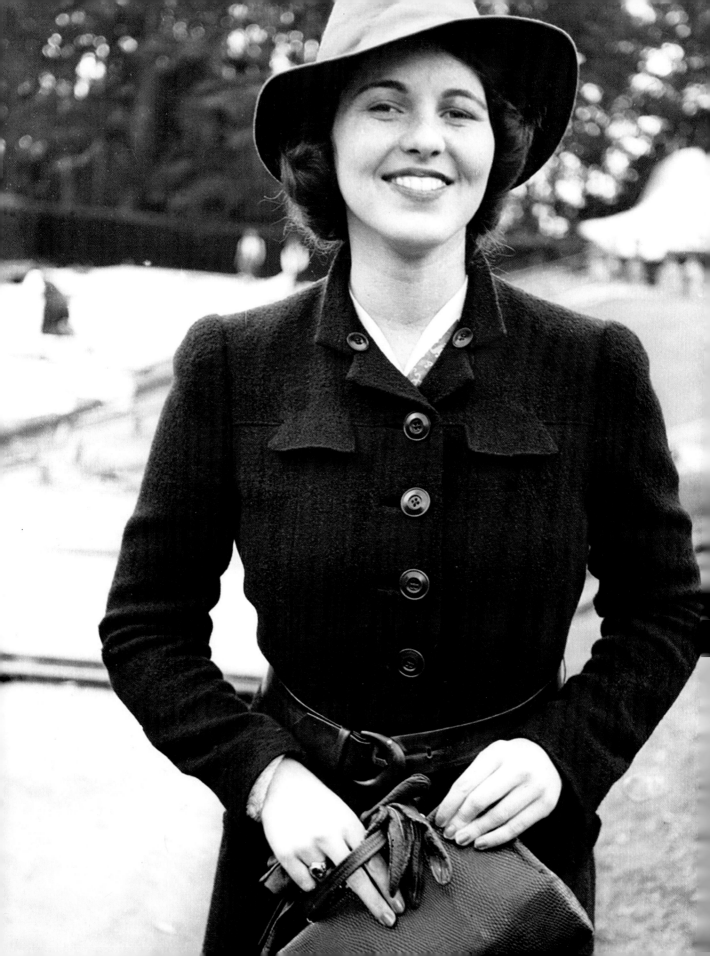

Opposite Rosemary Kennedy flashes the famous family grin in a picture taken before her mental instability and a failed brain operation moved the family to put her in an institution in the early 1940s. She died at age eighty-six in 2005. **Below** Short-lived happiness: on May 6, 1944, Kathleen Kennedy, twenty-four, married twenty-seven-year-old William John Robert Cavendish, the Marquess of Hartington, and Joe Jr. was right there behind them for the ceremony. None of the three was to live out the decade. The marquess and Joe were killed in action before summer's end, and Kathleen died in an airplane crash in 1948.

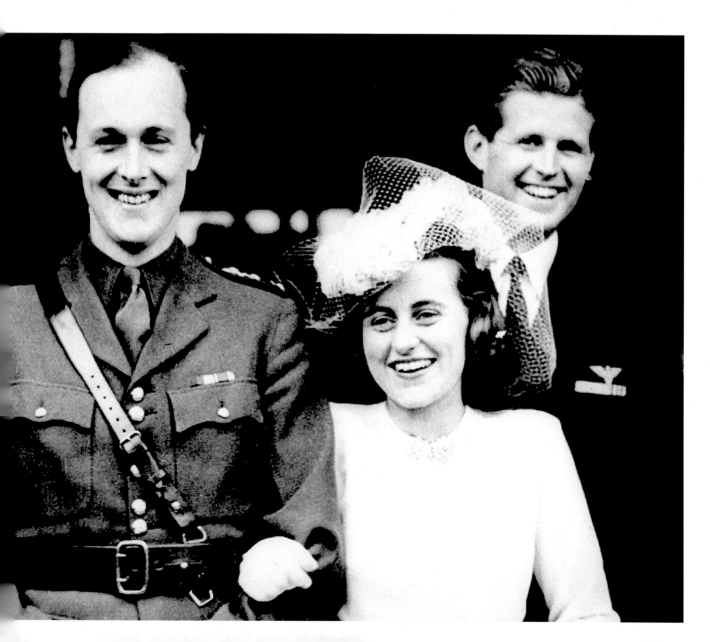

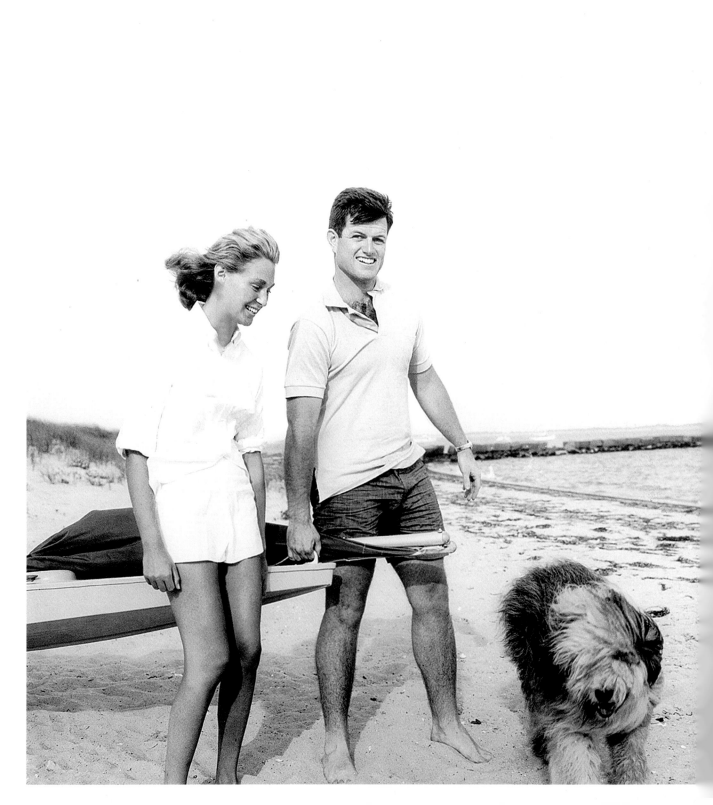

I arranged for a fellow freshman to take the examination for me. What I did was wrong and I have regretted it ever since. The unhappiness I caused my family and friends, even though eleven years ago, has been a bitter experience for me, but it has also been a valuable lesson.

—Senate candidate Edward M. Kennedy, commenting on his cheating at Harvard in 1951, in a March 30, 1962, interview with *Boston Globe* reporter Robert L. Healy

The 1950s
From Harvard
to the Altar

Ted and Joan Kennedy, with Panda tagging along,
ready to set sail in July 1959.

In 1950, as brother Jack ran for a third term in Congress and Bobby
worked at the Justice Department as a lawyer with responsibilities in the Internal
Security (i.e., spy-catching) Section, Ted Kennedy, just graduated from Milton
Academy, was in his freshman year at Harvard College, where he proved to be an
average student who was pretty good at football. Barely a month into his college
career, he and his family were dealt yet another blow as his maternal grandfather,
"Honey Fitz," died at age eighty-seven after a half century of involvement, in office
and out, in Boston and Massachusetts public life. He had taken a special interest in
the teenage Teddy when his family was scattered about in the chaos of World War II,
passing on anecdotes and political advice.

Over the next ten years, the youngest Kennedy was always on the go, his
life one of ups and downs, but mostly ups: He joined with family forces to
help Jack move on to the U.S. Senate in 1952 and get reelected six years later.
And he watched the family grow as wedding bells rang over and over again:
Bobby married Ethel Skakel in June 1950, Eunice married R. Sargent Shriver
in May 1953, Jack married Jacqueline Lee Bouvier in September of that year,
Pat married Peter Lawford in April 1954, Jean married Stephen E. Smith in
May 1956, and last, as always with this family, Ted married Joan Bennett in
November 1958.

The one memorable low moment occurred at Harvard. In the last semester of his
freshman year, he and a classmate were expelled after Ted had persuaded his friend
to take an exam for him.

A few months later, a chagrined Kennedy stunned his family, especially his father, by joining the Army at a dangerous time—a year after the start of the Korean War—but his two-year stint far from the battlefield was mostly uneventful, the highlight perhaps being a tour of duty at NATO headquarters in Paris. In the fall of 1953, he and his classmate were accepted back by Harvard, but varsity football was out for Kennedy; he was on probation for the year. By 1954 he was on the team but in a substitute's role that denied him his letter. The next year, though, he made first team as a tight end and started every game for a poor Harvard team (2–7, including a 21–7 loss to Yale).

With his diploma in hand after commencement in 1956, Ted spent the summer in Europe, then enrolled in law school in Virginia. During his first year there, he had occasion to visit Manhattanville College in New York, where a Miss Joan Bennett was in school. From all accounts, both were smitten at first sight and a busy courtship ensued, one that gave Joan a little sense of what it was like to be part of the energetic, tight-knit Kennedy clan. The couple were married on November 29, 1958.

Ahead lay graduation from law school the following June and a first-team role in the most important Kennedy family endeavor ever: the making of a president. As expected, after narrowly missing the vice presidential nod in 1956, Jack was going to run for the Democratic nomination in 1960, and his youngest brother would be an integral part of the operation. Ted's plans for his own future would have to wait. The uncertain freshman of 1950 had come a long way in a short time.

Life After "Honey Fitz"

There was no holding back John Francis "Honey Fitz" Fitzgerald when it came to revisiting stories of electoral battles won and lost during his long life in active politics and, afterward, as a keenly interested spectator. When he was in his eighties, as he was during most of the 1940s, the three-term congressman and two-time mayor of Boston taught a weekly course in Boston political history from his hotel suite in the city. He had just one pupil, his youngest Kennedy grandson.

A boarding student during those years at the Fessenden School in Newton and at Milton Academy while the rest of the family was working the larger world, Teddy would make his way into nearby Boston on weekends to be with his grandfather, a man with few peers when it came to the history of the city and its legendary civic figures. As he had done as a young father with his daughter Rose, the now old man took walks with her youngest boy, pointing out places of historical interest along the cityscape while passing along the political lore in which he had been a central player some fifty years before. Teddy relished the experience.

On October 2, 1950, "Honey Fitz" died at age eighty-seven. A month after moving onto a bigger stage, Harvard College, Teddy had lost his cherished link to the Fitzgerald side of his family and to old Boston.

32

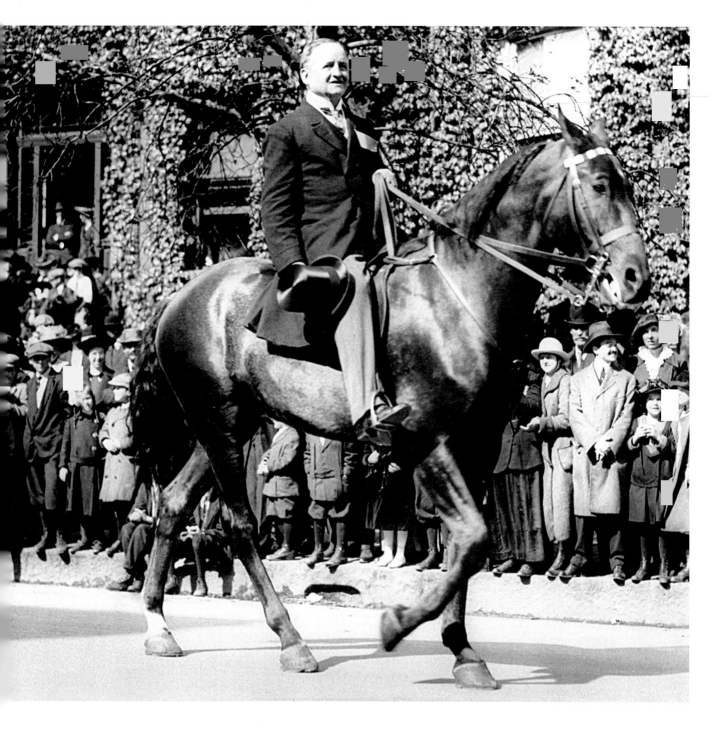

His Honor the Mayor, John F. "Honey Fitz" Fitzgerald, on New Year's Day in Boston in 1913. Three decades later, the teenage Ted Kennedy would listen with rapt attention to his grandfather's recollections about his glory days as a Boston political headliner.

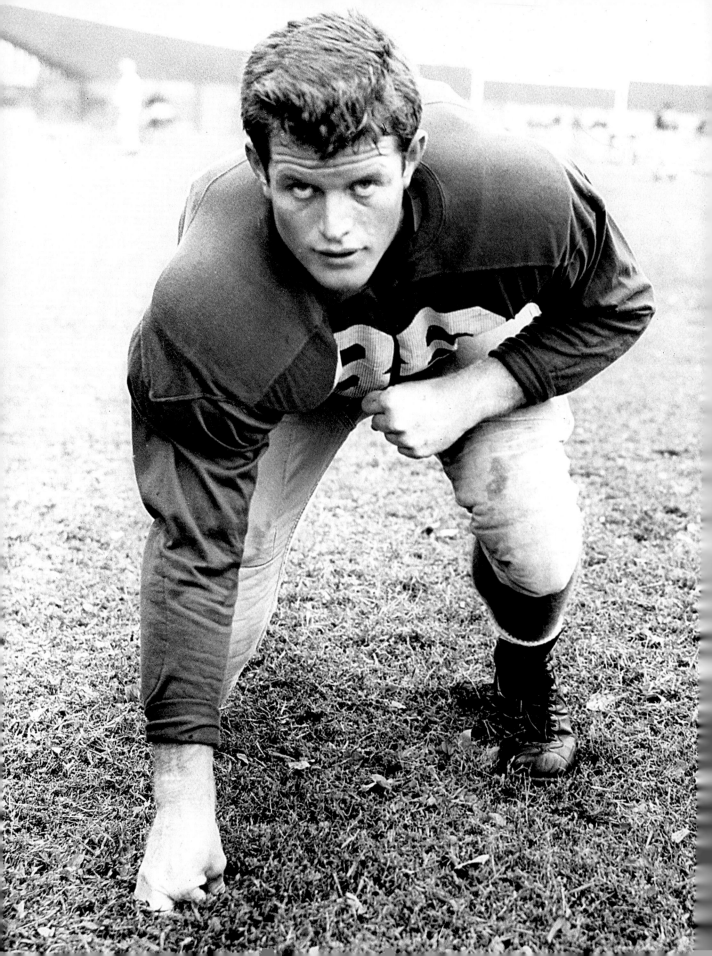

Undergrad Interrupted

Ted Kennedy was diligent enough in his studies to get to the next level without much fuss, and sometimes with honors. But there was a black mark on his résumé. As a freshman at Harvard in 1951, he persuaded a classmate to take a Spanish exam for him, and when both were caught in the act by a teaching assistant, they were dismissed from the college, though good behavior earned them a second chance a few years later.

Few outside of Harvard and the family knew of the incident initially, but when Ted entered the race for a U.S. Senate seat in Massachusetts in 1962, the family realized that it would be best to get the story out and the scandal behind them. After much discussion between the family, including President Kennedy, and the *Boston Globe*, the newspaper published a page one story on March 30, 1962, under the straightforward headline "Ted Kennedy Tells About Harvard Examination Incident." The state's voters on the whole seemed unconcerned; he went on to win the election handily.

During the 1950s, Ted Kennedy was seemingly here, there, and everywhere: two years in the Army after leaving Harvard, back to Harvard to get his football letter and his diploma, then on to the University of Virginia Law School, a summer at The Hague Academy of International Law, participation in his brother's Senate campaigns, and still time to win the hand of a young lady from New York.

He had inherited the legendary Kennedy drive, and it was in high gear.

Like his brothers, the youngest Kennedy loved to play football. In the 1955 game against traditional rival Yale, he caught a touchdown pass from his tight end slot for Harvard's only score in a 21-7 loss.

Friends of Jack

As active as his own life was throughout the 1950s, Ted Kennedy never forgot what was most important: attention to family affairs. It was a decade of troubling times, the key events being the Korean War and the assault on domestic communism—and the Bill of Rights—by Wisconsin's Republican senator, Joseph McCarthy (incidentally, a favorite of Joe Sr. and, for a time, Bobby's employer in the Senate). For the Kennedys it was an exciting time that, in the family tradition, had its upside—Jack's two election victories and his unexpected near win of the vice presidential spot on the Democratic national ticket in 1956, plus marriages for Jack, Eunice, Pat, Bobby, Jean, and Ted—and its downside—including Jack's numerous trips to the hospital for treatment of his ailing back and other conditions that he kept private.

The family particularly relished the results of the election of 1952 when Jack unseated Henry Cabot Lodge Jr., who had beaten the legendary James Michael Curley for the seat in 1936, and whose grandfather, Henry Cabot Lodge, had thwarted "Honey Fitz" in his last campaign, the senatorial race of 1916. In 1958, Jack's reelection bid, seen by all as a coasting win for the incumbent, proved to be just that as Ted, nominally the campaign manager but still in law school, watched Jack's veteran aides steer the campaign against GOP challenger Vincent J. Celeste to an overwhelming victory.

The brothers had set the stage for the ultimate political challenge; it was just two years away.

The brothers Kennedy, with Ted as campaign manager, await the numbers from Jack's smashing reelection win over Vincent J. Celeste in the 1958 U.S. Senate race. **Overleaf** Jacqueline and Jack enjoy a summer's day at Hyannis Port in 1957.

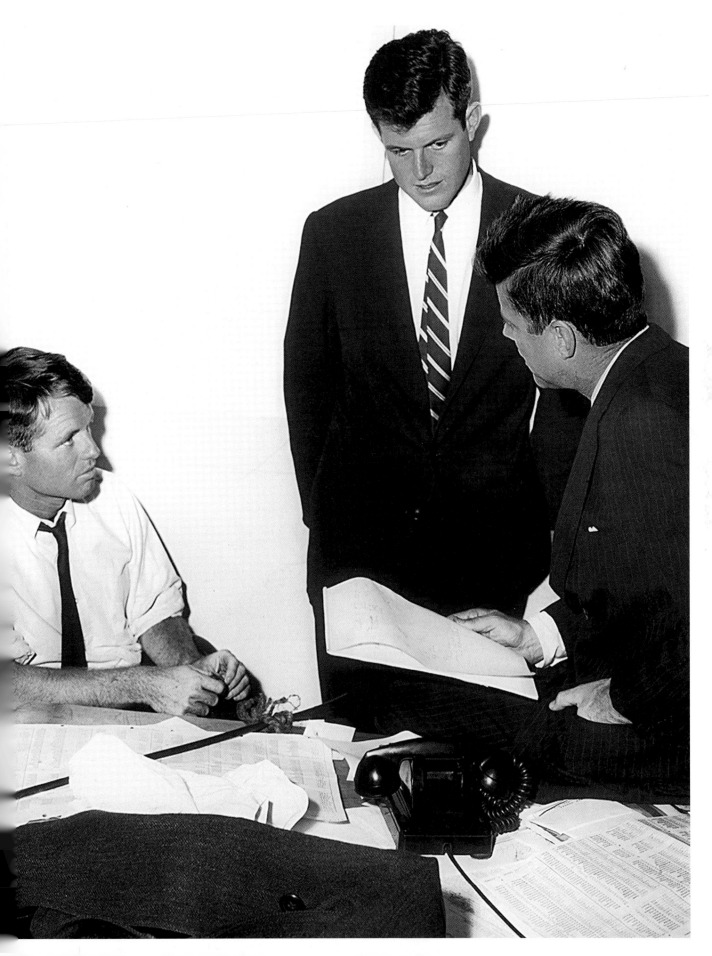

Fraternal session: Senior Ted and Senator Jack chat it up at the Harvard
Club, November 1955.

Joan Enters the Picture

In October 1957, Rose, Eunice, Jean, and Ted gathered at Manhattanville College in Purchase, New York, for the dedication of a family-funded gymnasium at the school that the three women had attended. Also on campus that day was Miss Joan Bennett, a debutante senior at the college, who joined the Kennedys and college officials at a party honoring Rose for her philanthropy. "Ted walked across the floor and introduced himself," Joan later told the *Globe*. It was a successful match from the get-go, and an engagement soon followed. But with Ted in law school and helping to manage Jack's reelection campaign, courting was done in sporadic fashion whenever Ted could break free of his crowded schedule.

Anecdotes about the engagement abound, and one story bears the imprint of Joan's father, Harry, a New York advertising executive: "Ted called me at the office and made an appointment to come to ask, formally, for my daughter's hand. I remember the interview. We sat stiffly and discussed the weather. Then he asked the traditional question. It was all a new experience for me, so I came back with the traditional reply. I asked him if he could support my daughter in the manner to which she was accustomed."

They made it to the altar in November 1958, with Jack as Ted's best man. After a year or so of prepping, Joan was officially in the family loop. The marriage wasn't destined to last, but its dissolution was far down the road. Now was the time to begin a family and get Ted rolling toward a life of public service.

42

Newlyweds Ted and Joan (Bennett) Kennedy all aglow on the steps of
St. Joseph's in Bronxville, New York.

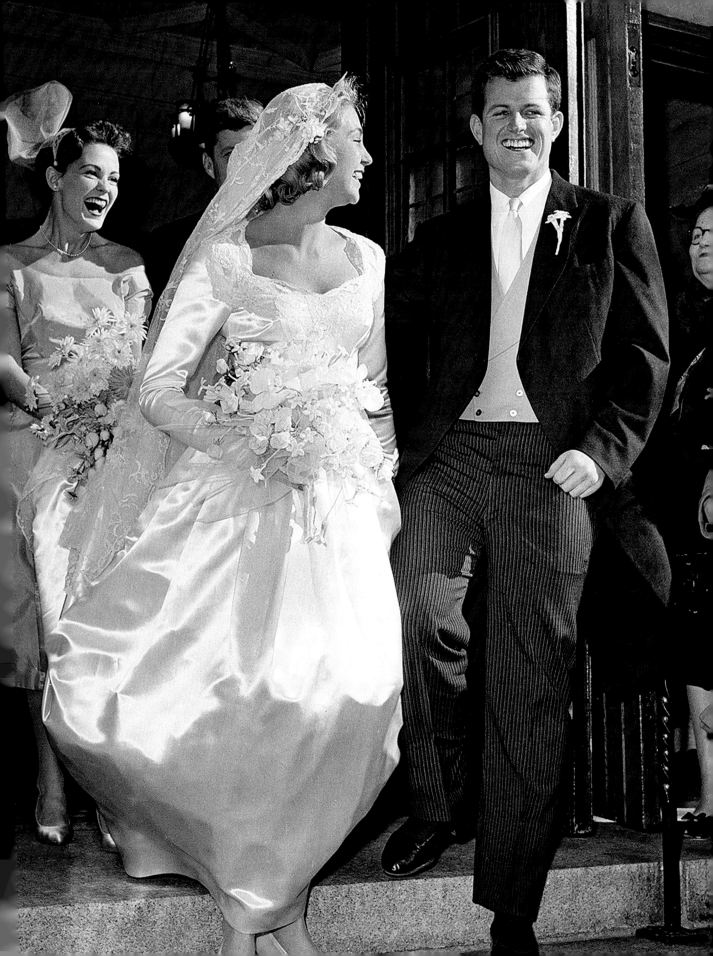

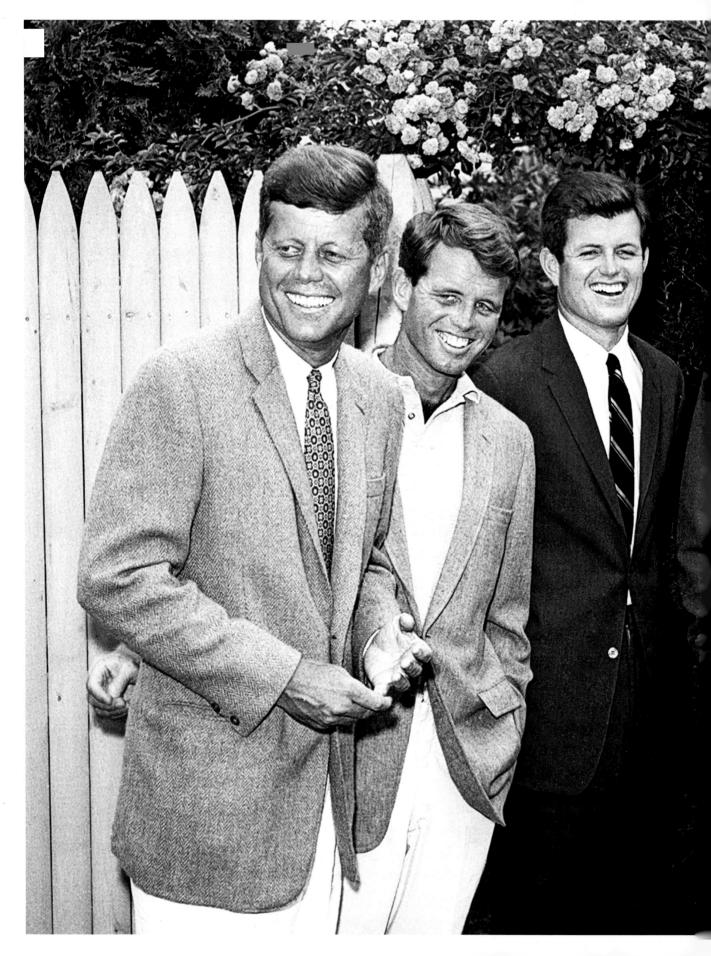

Whatever may be the sacrifices he faces, if he follows his conscience—the loss of his friends, his fortune, his contentment, even the esteem of his fellow man—each man must decide for himself the course he will follow.

—Ted Kennedy, July 1969, addressing the people of Massachusetts a week after the fatal accident at Chappaquiddick

The 1960s
Birth and Death in Camelot

The boys of summer, 1960: The campaigning Kennedy brothers at a press conference at Hyannis Port in July, days after Jack won the nomination for president at the Democratic National Convention in Los Angeles.

The 1960s were a time of triumph, tragedy, and untimely death for the nation and for the Kennedy family as the country grappled, often violently, with issues of war and peace, the economy, and the promotion of long-overdue civil rights for its minority populations. The Kennedy men—John and Robert and Edward—confronted the tumult head-on and made national politics and governance a family affair, Camelot style, if just for a while. Only the youngest survived to meet the 1970s. He was the brother the president called "the best politician in the family," the Kennedy whom both Jack and Bobby called "the hardest-working one of the bunch."

The year 1960 saw the full emergence of the Kennedys on the national scene as a remarkable political force when forty-three-year-old John defeated Richard Nixon to win the presidency. Power came to power, and by late 1962, Jack was in the White House, Bobby was the nation's attorney general, and Ted was seated in the Senate, elected after a controversial campaign in Massachusetts. The Kennedy era in America, it seemed, had only just begun.

But on November 22, 1963, Lee Harvey Oswald's rifle turned the Kennedy dream into a nightmare. By midafternoon, John Fitzgerald Kennedy was dead and a Texan named Lyndon Johnson was president. From that day until the decade's end, the family played a central role in a national drama in which assassinations took the lives of another Kennedy brother and Martin Luther King Jr., strife over a war in a faraway country ran deep, and political and cultural differences proved impossible to reconcile.

For the junior senator from the Bay State and his wife, Joan, the 1960s presented

joy—electoral triumphs, legislative achievements, the births of their three children,

Kara (1960), Edward Jr. (1961), and Patrick (1967)—physical trauma (a plane crash

while campaigning in western Massachusetts in 1964 in which Ted suffered a broken

back), and loss (the assassinations and emotional national funerals of his two older

brothers, Joan's miscarried pregnancies, and the death, late in 1969, of Ted's father,

who had been debilitated by a stroke eight years earlier). And then there was the

drowning of Mary Jo Kopechne in the waters off Chappaquiddick in July 1969, a

tragic event that left her family without a beloved daughter and the senator and his

extended family on an uncertain path to the future.

Cameras and reporters accompanied him on every step of this bittersweet journey,

recording each chapter in the history of a decade that was for him and for the nation

both the best and the worst of times.

Public moments, family moments, the good, the not-so-good, and the unendurable.

This was the stuff of Ted Kennedy's life as a young politician and family man, and

he kept on going, though he had his doubts. In his televised address to the citizens

of Massachusetts a week after the death at Chappaquiddick, he asked them to help

him decide if he should remain in the Senate: "Each man must decide for himself

the course he will follow. The stories of past courage cannot supply courage itself.

For this, each man must look into his own soul. I pray that I can have the courage to

make the right decision."

In the end, he stayed the course, though chastened, in private and in politics.

47

Make Room for Daddy

The sights and sounds of children being children were as much a part of the Kennedy way of life as the hurly-burly adult world of business and politics. Ted and Joan did their part in the making of a new generation during a decade of joy and sorrow for the family. First came Kara Anne, born in Bronxville, New York, on February 27, 1960. Then, on September 26, 1961, Edward M. Jr., was born in Boston. Giving birth was not easy for Joan, who experienced three miscarriages over the following eight years, but she carried a third child to term: Patrick Joseph, the twenty-sixth grandchild of Joe and Rose and named for his great-grandfather, was born on July 14, 1967.

In their formative years, the three children would see their father coming and going—mostly going—as his life seemed to be one continual political campaign, first for his brother Jack in 1960, then for himself in 1962 and thereafter, and for Bobby in 1964 and 1968. But there was always time for family—between baptisms—especially at their Cape Cod retreat in Hyannis Port, where the beach and the sailboats beckoned, and parents, grandparents, aunts, uncles, and cousins were eager to have some fun away from the outside world.

Ted and Joan show off eleven-month-old Kara in January 1961.

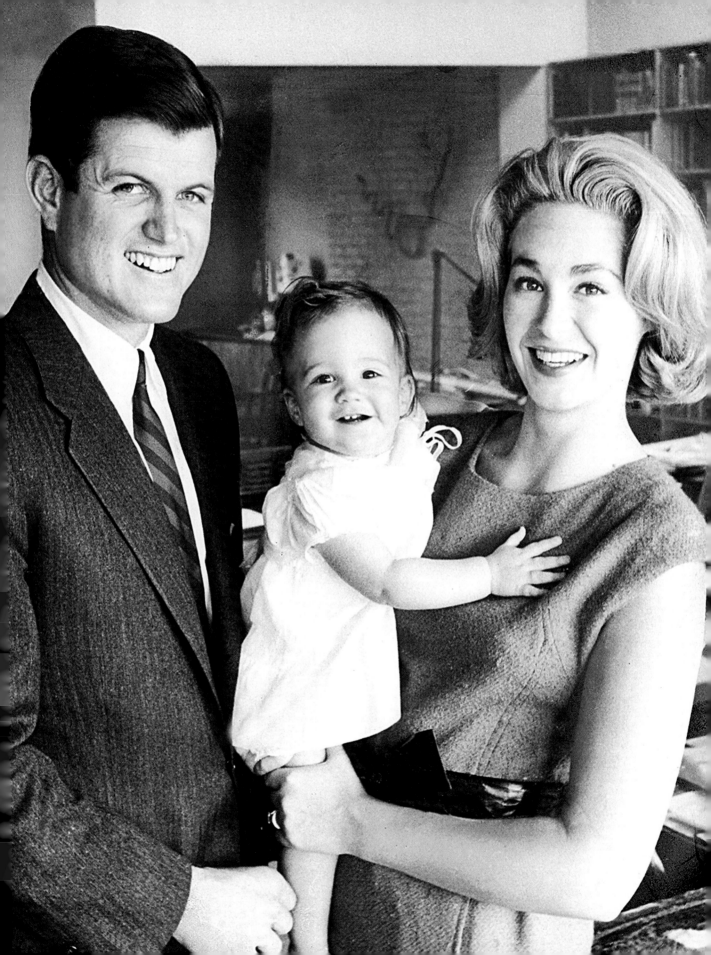

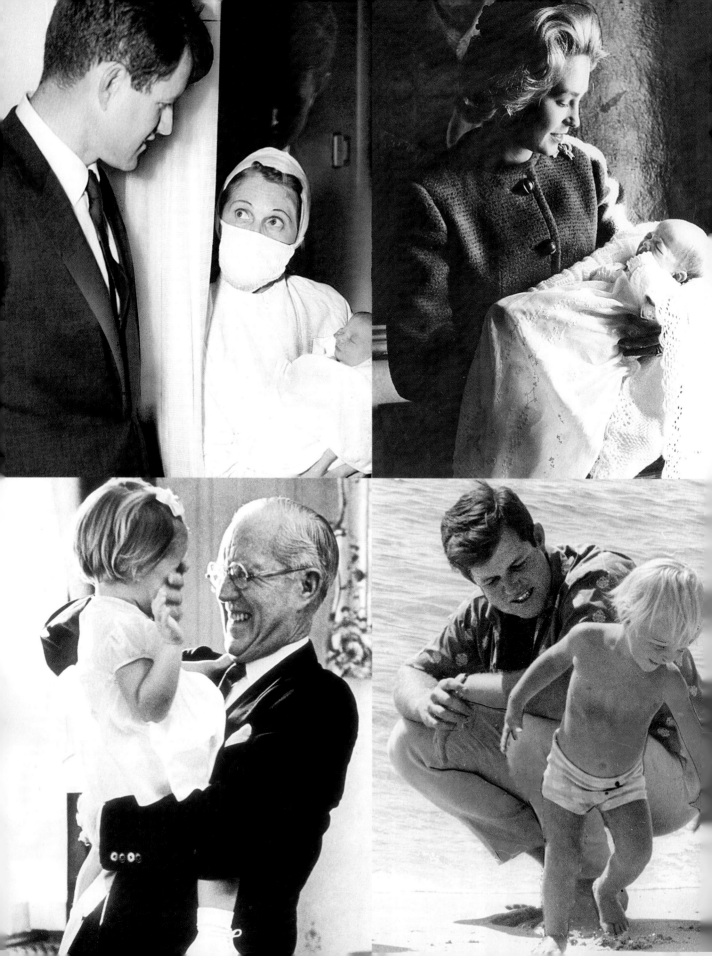

Children were the coin of the realm with the Kennedys, and Ted and Joan added three to the ever-growing family. **Opposite** (Top left) Ted gets a look at his namesake on the day he was born, September 26, 1961. (Top right) A month later, Joan holds Ted Jr. at his baptismal ceremony. (Bottom left) Joe the patriarch plays peekaboo with Kara in October 1961. (Bottom right) Ted and Teddy play in the sand at Squaw Island in the autumn of 1963.

Below Newborn Patrick Joseph Kennedy (in his grandfather's lap) and his family on the day of his baptism by Boston's Cardinal Richard J. Cushing in July 1967.

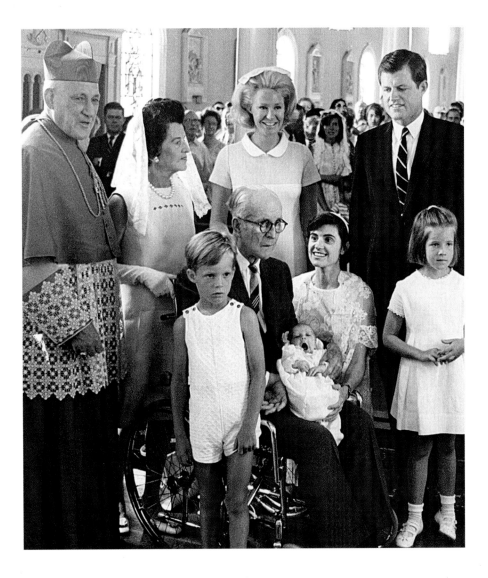

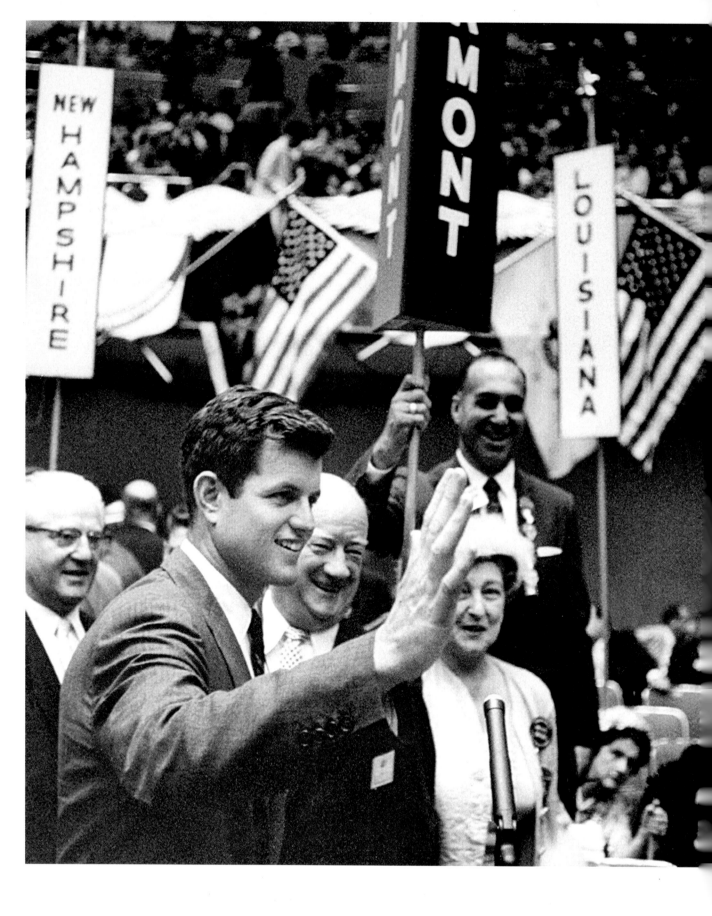

JFK for President

After John F. Kennedy announced his bid for president in January 1960, the family immediately moved into campaign mode for the Democratic nomination, with Ted being given responsibility for a number of Western states as well as some speaking duties around the country. Except for returning to New York to be with Joan at Kara's birth in late February, Ted spent seven weeks in Wisconsin, a critical state for his brother, who was bent on proving that a Catholic could win the nation's highest office. The *Globe*'s Bob Healy marveled at the young Kennedy's energy and commitment to his brother's cause, reporting from Wisconsin that "he bounces around at 5:30 in the morning the way most men do after their third martini of the evening."

JFK went on to take the Wisconsin primary easily, gain the nomination in August, and defeat Richard Nixon in the general election. From start to finish, Ted was always on the go, a relentless campaigner both one-on-one and among crowds. It was performances like this that caused his brother to praise him as "the best politician in the family."

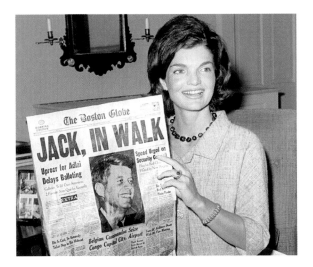

Opposite Ted waves to the delegates at the Democratic National Convention, July 1960. **Above** Jackie spreads the news about Jack's nomination.

53

Ted Goes to Washington

After working for thirteen months as a dollar-a-year assistant district attorney in the cops-and-robbers world of Massachusetts's Suffolk County, Ted announced in March 1962 that he would run for the office of senator, to succeed Benjamin A. Smith of Gloucester, a college buddy of JFK who had been named interim senator after the election in 1960.

It was a high-stakes decision made after intense consultation with his father and his brothers, who saw that it was by no means a guaranteed win. There was his youth and the fact that he had never run for any public office; there was the suggestion that Ted's election might mean one Kennedy too many in Washington (to which he often replied with a lighthearted "You should have taken that up with my mother and father"); and there was serious competition for the nomination in the person of Edward J. McCormack, the sitting attorney general of Massachusetts and the nephew of Speaker of the House of Representatives John W. McCormack.

As always, the Kennedys went all-out for the family man, and the candidate was his usual relentless self. But the turning point of the campaign may have come in an August debate a month before the primary when McCormack, on the attack throughout, pointed across the stage to Kennedy and said, "If his name were Edward Moore, with his qualifiations—with your qualifications, Teddy—if it was Edward

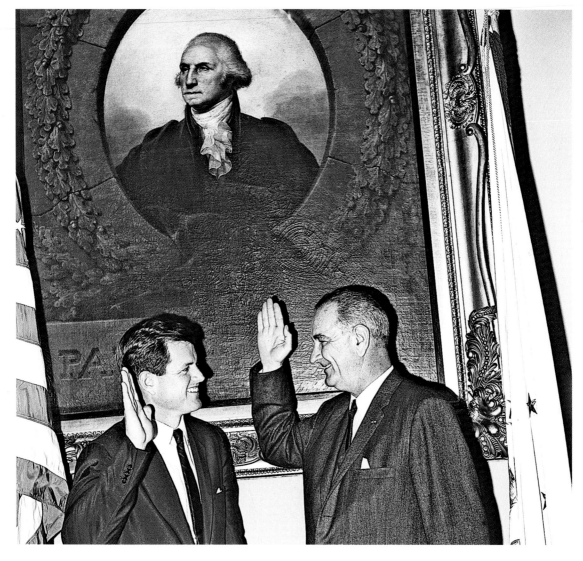

Moore, your candidacy would be a joke." In the aftermath, McCormack was widely
seen as a bully and Ted as a polite and earnest young candidate. He overwhelmed
McCormack in the primary by 200,000 votes and in November won by almost 400,000
votes over George Cabot Lodge, son of the man JFK had beaten in 1952 and great-
grandson of the man who had beaten "Honey Fitz" for a Senate seat in 1916.

It was on to Washington to join his brothers on the New Frontier.

55

Taking the oath: Vice President Lyndon B. Johnson swears in the newest senator
from the Commonwealth of Massachusetts at the Capitol in 1963.

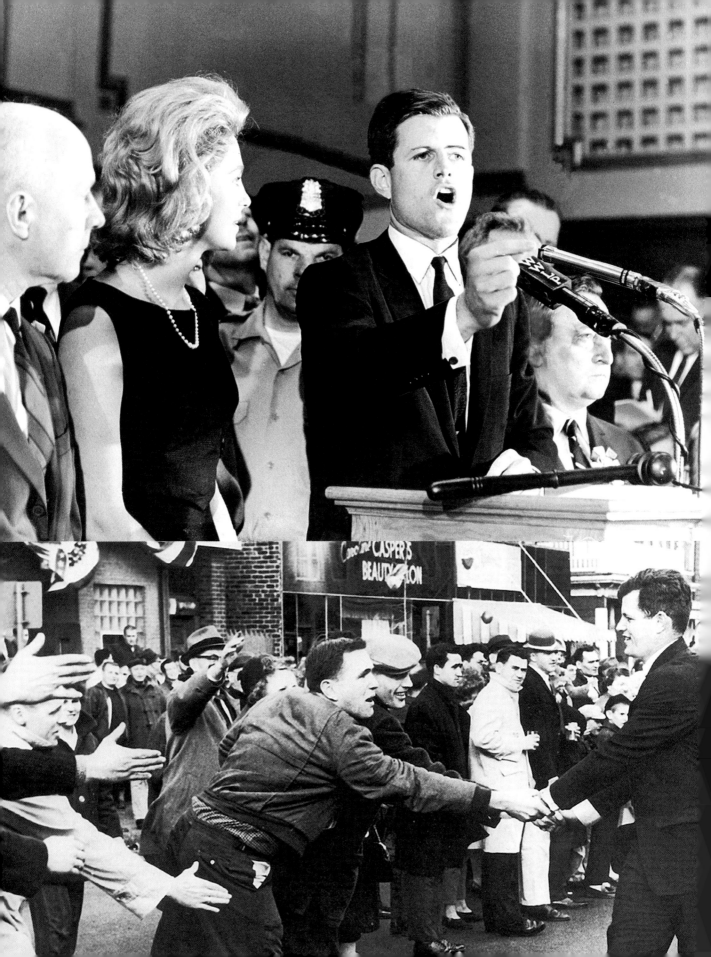

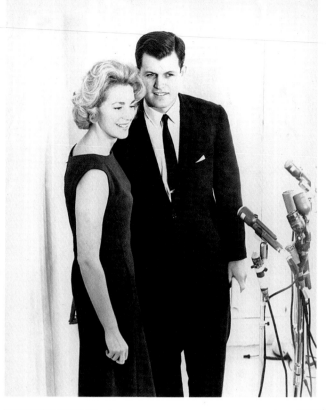

Opposite His brothers called Ted the hardest-working one of the bunch, and his campaign style gave substance to their claim. (Top) A fiery speech at the state Democratic Convention, where he was nominated for a U.S. Senate seat. (Bottom) The candidate takes to the streets in May 1962. **Above** Ted and Joan huddle before a press conference, March 1962. **Below** Window-shopping for votes in the North End in August 1962.

Opposite (Top left) Ted and Joan in the voting line in November. (Top right) Shaking hands with Republican opponent George Cabot Lodge before the pair appeared on *Meet the Press*. (Bottom) Greeting supporters at his campaign headquarters.

Below (Top left) Ted cultivated a following even before his Senate run, taking time out in the early 1960s to have a hot dog with the caddies at Hyannis Port Golf Course. More politicking: (Top right) The constant candidate getting feedback at Boston's Fish Pier. (Bottom left) Waiting to debate Edward J. McCormack at South Boston High School. (Bottom right) Seeking votes via placards.

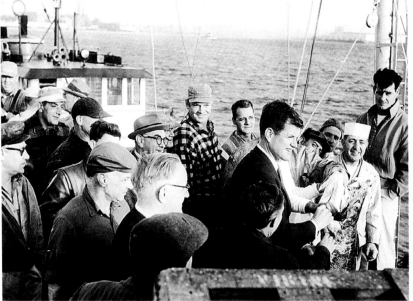
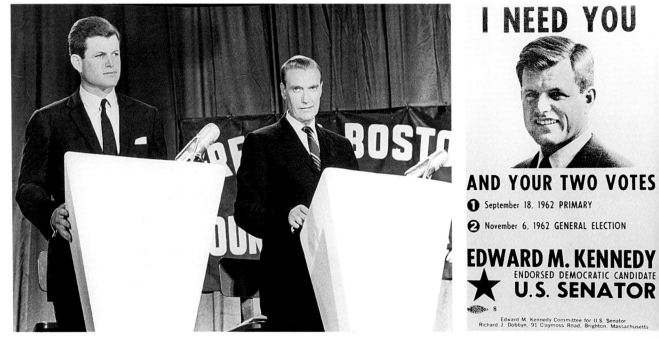

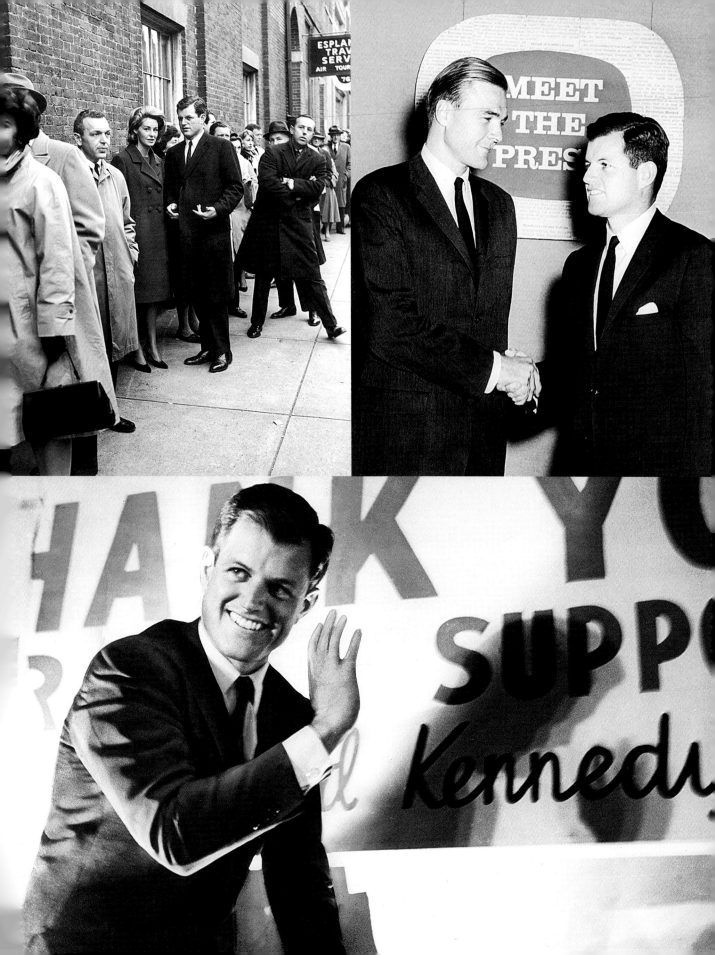

Death of a President

Freshman Senator Ted Kennedy was presiding over a sleepy session of the U.S. Senate in the early afternoon of Friday, November 22, 1963, when an aide rushed onto the floor to tell him that his brother the president had been shot in Dallas. A short while later, Bobby told him that Jack was dead.

Once again, the Kennedys rushed to come together in grief to bury one of their own who had died too young, this time the family's shining light. While a shocked world recoiled from the horror, Jackie, Bobby, and Ted moved to embrace one another and their loved ones as the president's body, attended by the eyes of tens of millions watching on-site and in their homes, was moved, step by somber step, from Texas to the Capitol Rotunda to St. Matthew's Cathedral, and finally to Arlington National Cemetery.

After talking with Bobby in the initial hours of the tragedy, Ted called his mother on Cape Cod. She told him she was worried about how Joe, who had suffered a debilitating stroke in 1961, would take the news. So Ted and his sister Eunice made their way to Hyannis Port, where Ted went to his father's room. The patriarch "showed no visible emotion as he listened to his son," according to a newspaper report. The senator returned to the capital on Sunday and, with his extended family, accompanied his fallen brother to his last services and final resting place.

"Ask not what your country can do for you . . . ask what you can do for your country."

President Kennedy in his inaugural address, Jan. 20, 1961.

Color portrait of President on Page 16.

The Boston Globe

MORNING EDITION

Reg. U. S. Pat. Off.

VOL. 184 NO. 146 · © 1963 · By GLOBE NEWSPAPER CO.

SATURDAY, NOVEMBER 23, 1963

Telephone AV 8-8000

32 PAGES—10c

WEATHER

SATURDAY — Partly cloudy, near 70.

SUNDAY—Fair.

High Tide
3:47 a.m. 4:01 p.m.
Sun Rises Sun Sets
6:44 4:17

Full Report on Page 24.

SHOCK...DISBELIEF...GRIEF

John Fitzgerald Kennedy, Born in Brookline, Massachusetts—Shot and Killed in Dallas, Texas, at Age of 46

Sniper's Bullet Cuts Down President
Jacqueline Cradles Dying Husband
Johnson Sworn In; McCormack No. 2

By ROBERT L. HEALY
Globe Reporter

WASHINGTON—A sniper's bullet brought death to President John Fitzgerald Kennedy at 2 p.m. Friday, changing with immeasurable impact the history of a shocked, disbelieving world.

The 35th President of the United States and son of Massachusetts became a martyr on a street of Dallas, Tex., to principles he carried to the nation in words and in action.

He answered in death what he said in his own Inaugural: "Ask not what your country can do for you—ask what you can do for your country."

His productive life was ended at 46. Three years ago he was the youngest man ever elected to the presidency.

A rifle bullet, fired into his head from the upper story window of a building at 12:30 p.m. Dallas time, turned an hour of triumph into sudden national disaster.

He never regained consciousness.

Mrs. Jacqueline Kennedy cradled the body of her husband in her arms as the open car sped to Parkland Hospital in Dallas.

John F. Kennedy, the first Catholic President in the history of the nation, died there after he was given the last rites of his church.

Eleven hours after the assassination, police charged a 24-year-old one-time Marine, avowed Marxist and pro-Castroite with the murder. Lee Harvey Oswald, who defected to Russia in 1959, was captured in a theater after slaying a pursuing police officer.

Cardinal Cushing, who performed the marriage of President Kennedy and baptized his children, will celebrate a funeral Mass at noon, Monday, in St. Matthew's Cathedral in Washington.

PRESIDENT Page 2

'Oh, No!'

A Wife's Anguish

By HELEN THOMAS

WASHINGTON (UPI)—The world which had toasted Jacqueline Bouvier Kennedy on many a yesterday wept for her Friday.

This once most fortunate of lovely ladies came home from Dallas, Tex., bearing a burden of grief too heavy for utterance.

At midday she had said gaily to her husband, "You can't say Dallas wasn't friendly to you."

The crowds had been huge, their cheers deafening as they rode side by side through the city.

Somehow the assassin's hastily fired bullets had missed her, seated inches away on the President's left.

It was the second time in 3½ months that she had seen death strike a loved one while sparing her.

On Aug. 7, 1963, she had given birth prematurely to Patrick Bouvier Kennedy. Two days later he died. She made a brave recovery. On Oct. 1 she left for a two-week recuperative vacation in Greece and the Mediterranean.

JACQUELINE Page 2

AN INSTANT—A stunned Mrs. Kennedy seeks to help her dying husband, slumped over beneath her. Secret serviceman leaps on car to give aid. Three shots from sniper's bullet turned cheerful scene into a nightmare. (AP)

Texan Held as Killer

Castroite Accused; How President Was Slain

DALLAS (UPI)—Lee Harvey Oswald, 24, a pro-Castroist who defected to Russia in 1959, was charged Friday with the assassination of President Kennedy, who was killed with a high-powered

...ald made no confession ...sisted he knew nothing ...the assassination of the ...ent or the serious ...ting of Texas Gov. John ...ly.

...acled, his face battered ...ght with the police who ...ed him in a movie ...less than four miles ...the assassination scene, ...was taken before Justice of the Peace David John...r arraignment.

Police Chief Jesse Curry said he would be brought before a Grand Jury next week.

Police made paraffin tests on Oswald several hours before he was charged formally.

Police also charged the 24-year-old Marine reject with the murder of a Dallas police officer shortly after the President was slain by a sniper firing a military rifle from the window of a building in downtown Dallas.

Capt. Will Fritz of the homicide department said it had been established Oswald was in the building from which the President was killed at the time the shot was fired. Police were making paraffin tests on Oswald's hands for marks of gunpowder.

Police made paraffin tests on Oswald several hours before he was charged formally.

SUSPECT OSWALD

ASSASSINATION Page 2

His Home State Reacts

TRIBUTES—"My heart is broken with grief over his martyrdom"—Cardinal Cushing. This and other eulogies for President Kennedy on page 21.

CANCELLATIONS—Radio and TV cancel programs. Many sports and enter-tainment events postponed. Page 7, 23.

McCORMACK—Bay State congressman guarded by Secret Service as he becomes next in line to succeed to the Presidency. Page 6.

SCHOOLS—Gov. Peabody urges education officials to omit classes Monday.

...As Body Lies in State

PRESIDENT KENNEDY's BODY will lie in the East Room at the White House Saturday to be viewed by his family and top government officials.

THE BODY WILL BE MOVED to the Capital Rotunda Sunday at 1 p.m. where the public will be permitted to file past the bier until 9 p.m. and again Monday from 9 a.m. to 10 a.m.

CARDINAL CUSHING will sing a Pontifical Requiem Mass at noon Monday at St. Matthew's Cathedral, Washington.

BURIAL expected to be in Holyhood Cemetery, Brookline.

'I'll Do My Best—LBJ'

By DON IRWIN

WASHINGTON—"I will do ...t. That is all I can do. I ...your help and God's" ...was President John...ledge and prayer upon ...val at 5:58 p.m. Friday ...ington to take over the

Johnson has used the suite as his "downtown office" for the past two years.

At his 45-minute meeting with the legislative leaders of both parties in House and Senate, the new President was reported to have said "it is more

The 36th President looked grim but self-controlled as he stepped before a bank of microphones and television cameras on the floodlit ramp at Andrews Air Force Base to make a brief statement, his first since he was sworn in at

Mourning time in the capital: The family laid Jack to rest in stately ceremonies as the whole world watched. **Below** John Jr. famously salutes his fallen dad as Ted, Caroline, Jackie, and Bobby look on. **Opposite page** (Top) President Johnson lays a wreath at a service in the Capitol Rotunda. (Bottom) The family leaves the White House for the funeral march, Ted to the left of the grieving widow.

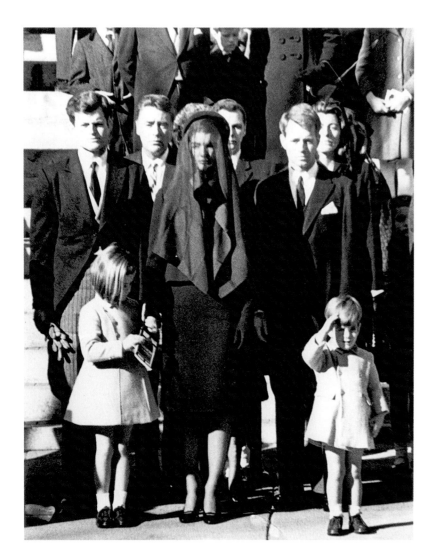

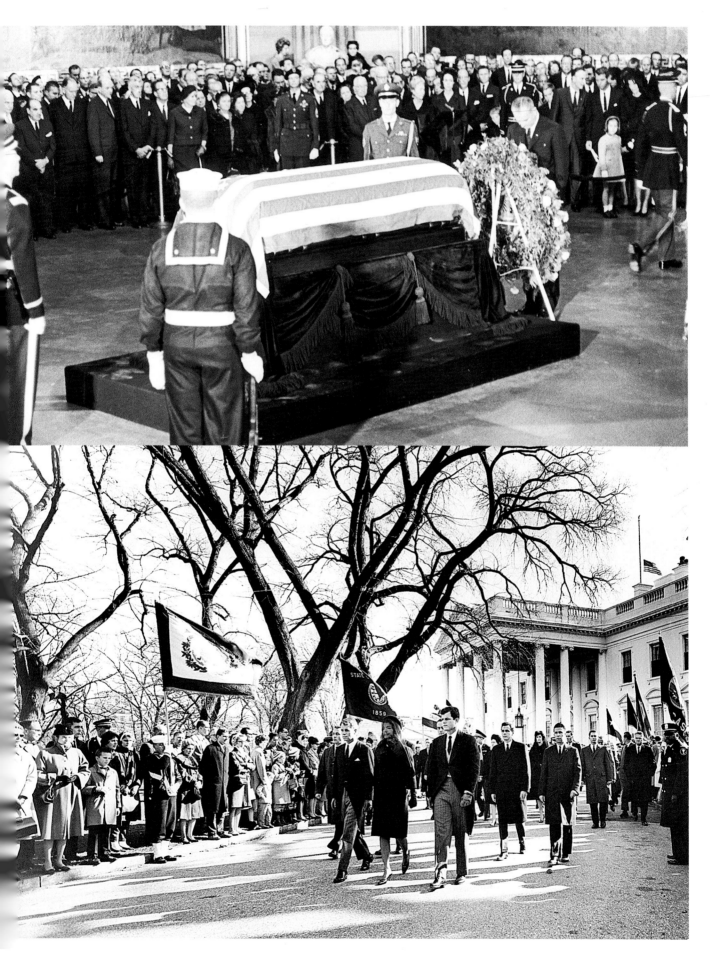

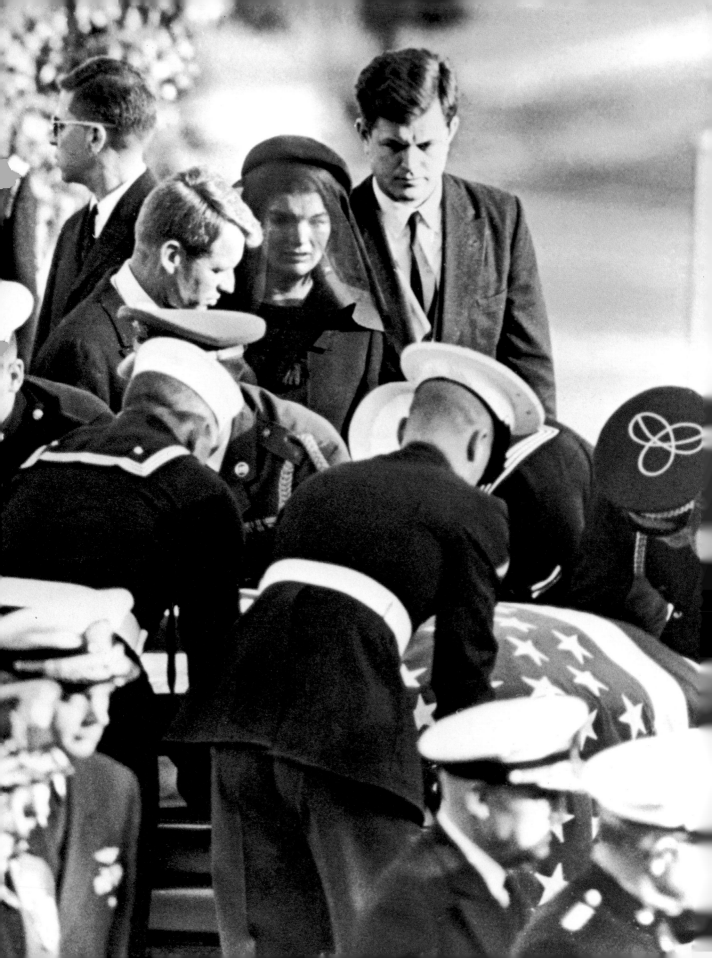

Opposite The military honor guard lowers the casket containing the president's body at Arlington National Cemetery as Bobby, Jackie, and Ted take a last look.
Below The cortege makes its way to the cemetery grounds.

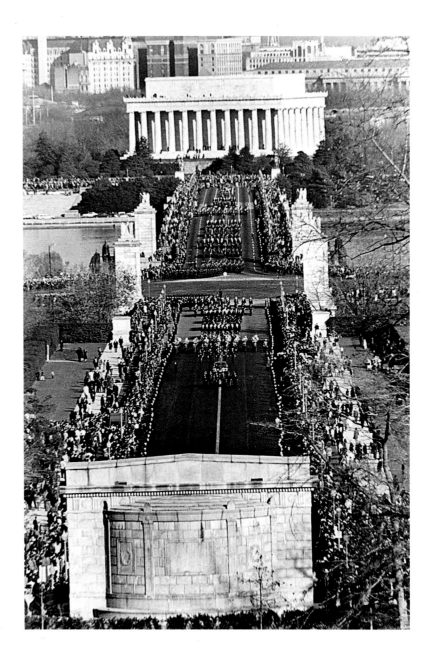

A Back-Breaking Crash

Immediately after voting in the affirmative on a major civil rights bill that the Senate approved in the evening hours of June 19, 1964, Ted Kennedy boarded a small twin-engine plane that was going to take him to the state Democratic Convention in West Springfield, Massachusetts, where he was scheduled to accept the party's nomination for his first full term. Joining him for the ride were Senator Birch Bayh of Indiana, who was going to address the convention; his wife, Marvella; and a close Kennedy aide, Ed Moss. When they arrived near their destination, in Southampton, a dense fog had settled in, so the pilot, Ed Zimny, prepared for an instrument landing, which, officials said later, he apparently misjudged. The plane hit a tree in an apple orchard, shearing off portions of both wings and cartwheeling to a rest against another tree. "The front of the plane opened as though a kitchen knife had sliced through it," Bayh told the *Globe* the next day. "Ted was crumpled up on the floor. My wife and I struggled . . . on all fours and somehow scrooched him through the window and dragged him over to the hill." The Bayhs walked barefoot over to a road where they flagged down a car and began the rescue process.

The pilot died instantly, and Moss passed away several hours later. Ted was rushed to Cooley Dickinson Hospital in Northampton in a state of shock. He was treated there, and later at New England Baptist Hospital, by successive teams of doctors

66

Ever the campaigner: A tightly wrapped Ted signals he's okay as he and Joan arrive at the New England Baptist Hospital in Boston's Mission Hill to continue his recuperation from a plane crash in western Massachusetts.

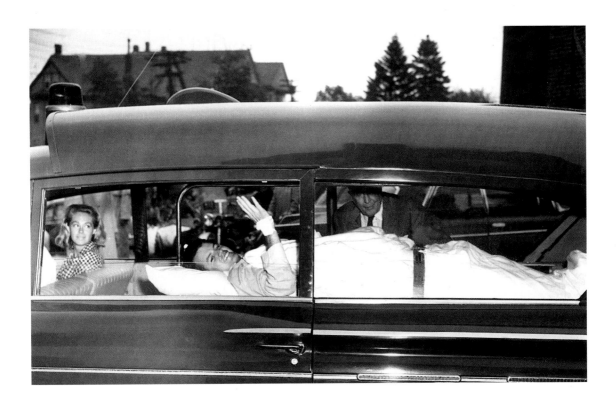

for severely fractured major vertebrae, broken ribs, multiple bruises, and suspected internal injuries. The Bayhs suffered minor injuries.

Recovery came slowly to the battered Kennedy, who was in a reelection fight. For six months he remained in New England Baptist Hospital, rendered immobile while the vertebrae slowly healed. Reelected by a large margin in November, he walked out on December 16, ready to press on in Washington though his back was still in a brace.

67

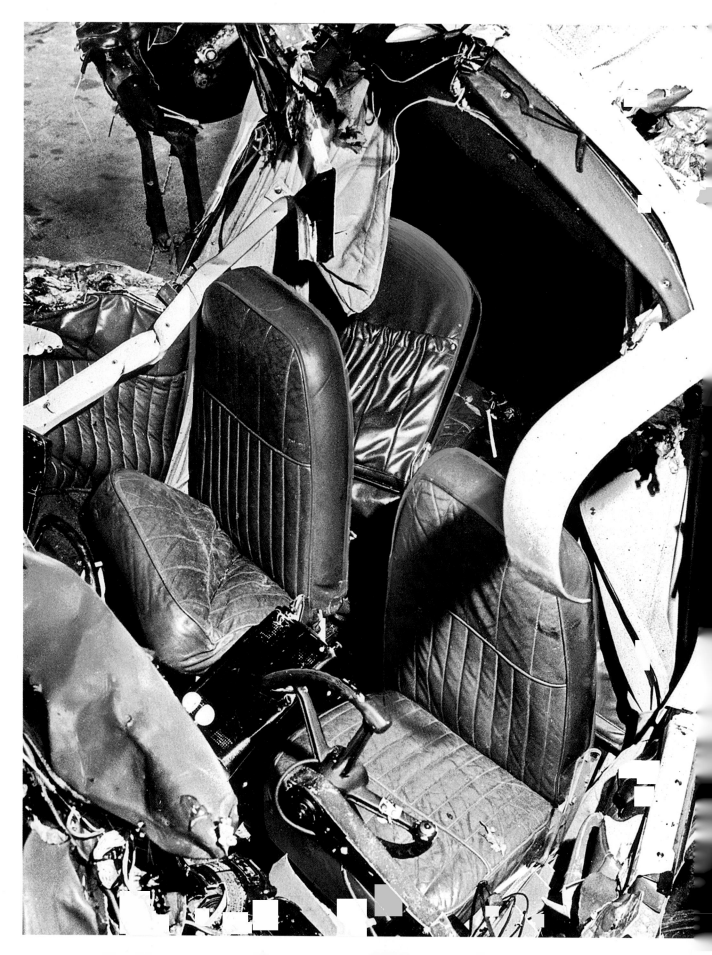

Opposite By late June, investigators had pieced together some parts of the plane after the crash into a Southampton apple orchard. **Right** (Top) Joan keeps a watchful eye on her stricken husband, four months after the accident. (Bottom) With canes at the ready, he embraces his father outside the hospital.

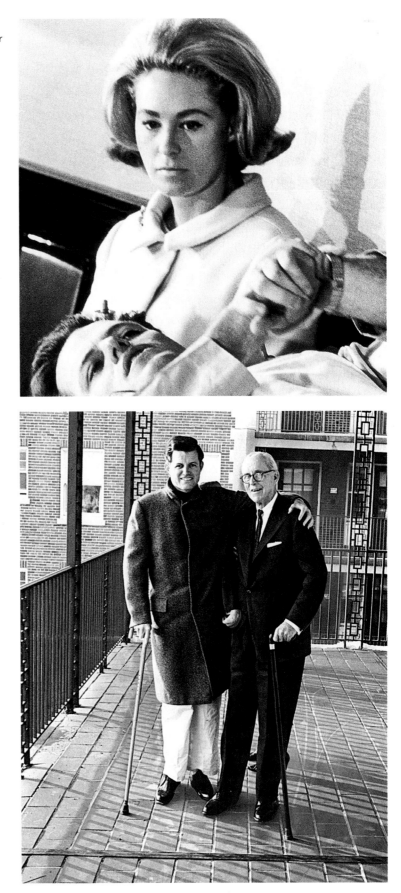

Learning to Legislate

Despite the severity of the plane crash in Southampton, Ted recovered quickly with the help of his attentive family, led by Joan and Bobby, who helped keep the legendary Kennedy drive in high gear. The brothers, one newly elected and one reelected, walked into the U.S. Senate chamber together in January 1965, a study in grit and purpose.

Ted had been a model freshman since he first took up his seat in 1963: He was seen but rarely heard. But he paid attention to his key issues—civil rights, health care, immigration—and on April 9, 1964, during a debate on a major civil rights bill,

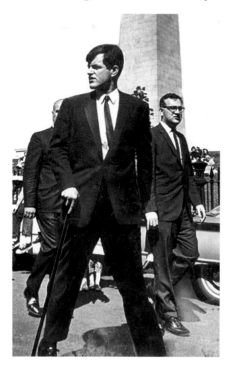

Ted gave what he said was his true maiden speech as a senator. Citing his assassinated brother's preoccupation with the bill and Lyndon Johnson's promise to keep working the issue, he said that it was past time that unfair barriers were taken down. His vote helped enact historic legislation to end racial discrimination. The battle for voting-rights legislation lay ahead, but the wall of bias had been breached.

Not every fight was as noble. In 1965, Ted stumbled badly, failing to get the Senate to

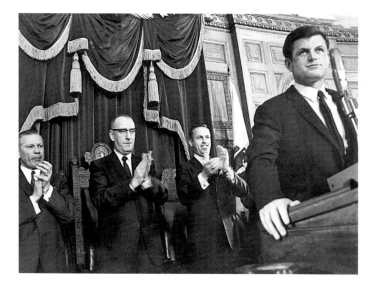

approve the nomination to a federal judgeship of Boston Municipal Court Judge Francis X. Morrissey, a longtime Kennedy hand who was virtually a butler to old Joe.

Then there was Vietnam, the war that kept getting bigger. At first a supporter of Lyndon Johnson's strategy for stopping what many saw as Communist aggression in Southeast Asia, Kennedy used the knowledge and impressions gained from two extensive fact-finding trips to Vietnam, in 1965 and early in 1968, and from visits to campuses around the country, to begin to question America's purpose in the region and the Vietnamese government's willingness to carry on meaningfully. LBJ was not pleased.

But the president was making a losing case. In February 1968, the North Vietnamese launched the Tet Offensive, which proved to be a turning-point political victory if not a battlefield success; in mid-March, Bobby announced that he would seek the Democratic nomination for president; and in late March, Lyndon Johnson told the country that he would not run again.

71

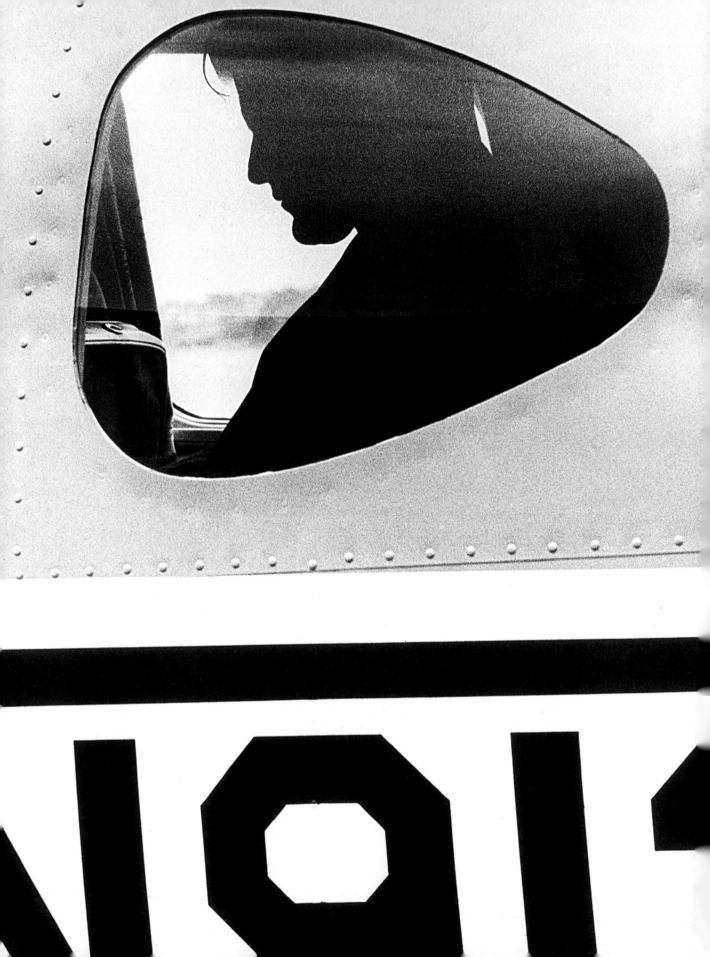

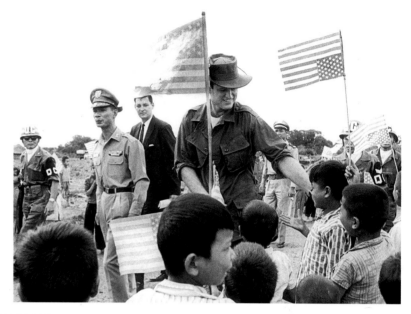

Opposite The familiar silhouette of Senator Ted Kennedy aboard the Cape Cod shuttle plane to Logan Airport in Boston. **Right** Always on the go, and not just domestically, he traveled to Vietnam in November 1965 and checked out the situation in Ban Me Thout village. **Below** Keeping in touch at his office in Washington.

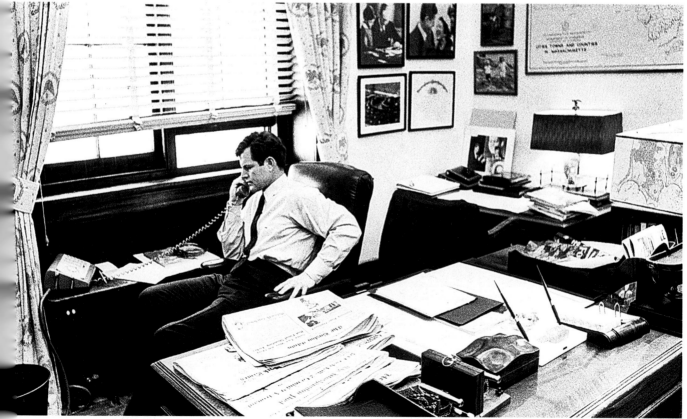

My brother need not be idealized or enlarged in death beyond what he was in life, to be remembered as a good and decent man, who saw wrong and tried to right it, saw suffering and tried to heal it, saw war and tried to stop it.

—Edward M. Kennedy, in his eulogy of Robert Kennedy at St. Patrick's Cathedral, New York, June 8, 1968

Ted and Bobby and Martin

As Ted was coming to grips with his changing views on Vietnam in early 1968, Bobby was toying with the prospect of challenging President Johnson in what he assumed would be a reelection bid. At first he demurred, thinking LBJ unbeatable as an incumbent. Then came the double surprises of Tet and Eugene McCarthy's improbable strength in mustering support for the nomination, especially among the antiwar young. RFK, with Ted's lukewarm endorsement, jumped into the fray on March 16. Eleven days later, the president provided the biggest surprise of all: he said he would not run for reelection.

Just a week later, on April 4, James Earl Ray shot and killed Martin Luther King Jr. in Memphis, igniting riots that led the Kennedy brothers to add their strong voices to pleas for peace and understanding.

After some electoral ups (Nebraska, Indiana) and downs (Wisconsin, Oregon), Bobby moved on to California, where he won the primary on June 4. After he finished addressing a hotel room full of supporters in the early hours of the next day, Sirhan Sirhan shot him dead.

Once again, the family gathered for the funeral rites of a loved one, led in mourning by the last brother standing, who delivered a moving eulogy in St. Patrick's Cathedral in New York that included these words: "As he said many times, in many parts of this nation, to those he touched and who sought to touch him— 'Some men see things as they are and say why? I dream things that never were and say why not?' "

Later that day, after an eight-hour train ride from New York to Washington, Robert Kennedy was buried shortly before 11 P.M. at what *Globe* reporter James S.

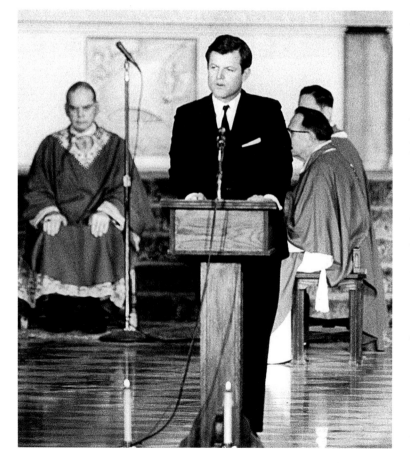

Doyle called "perhaps the simplest ceremony ever seen at Arlington National Cemetery. His body was borne to the site of his brother's grave in light from candles held by 2,000 friends and by other hundreds of strangers who had waited through the day and into the night along the cemetery roads."

75

Speaking at his brother Bobby's funeral
mass on June 8, 1968.

Linked in life and death: Martin Luther King Jr. and the three Kennedy brothers shared a commitment to civil rights, but by early June 1968, only one of them was left to carry on toward their common goal of equality in American life. The minister was gunned down in Memphis on April 4, and Robert Kennedy was assassinated moments after claiming a victory in California's presidential primary on June 5.

Below MLK addresses a crowd at the Massachusetts State House in 1965.

Opposite (Top) The brothers Kennedy deplane at Boston's Logan Airport and share a conversation. (Bottom left) MLK, RFK, and LBJ converge outside the White House. (Bottom right) The unforgettable horror of Bobby Kennedy on the floor at the Ambassador Hotel in Los Angeles after being shot by Sirhan Sirhan on June 5, 1968.

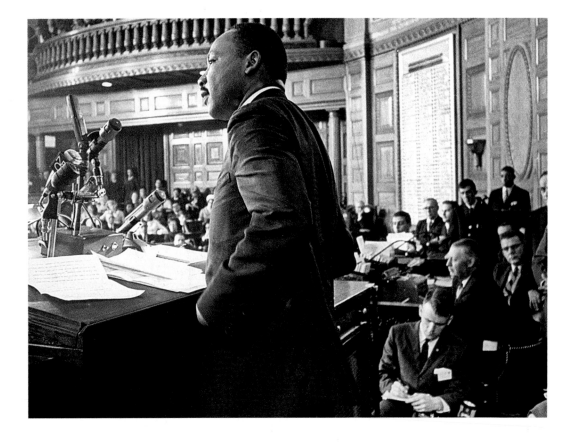

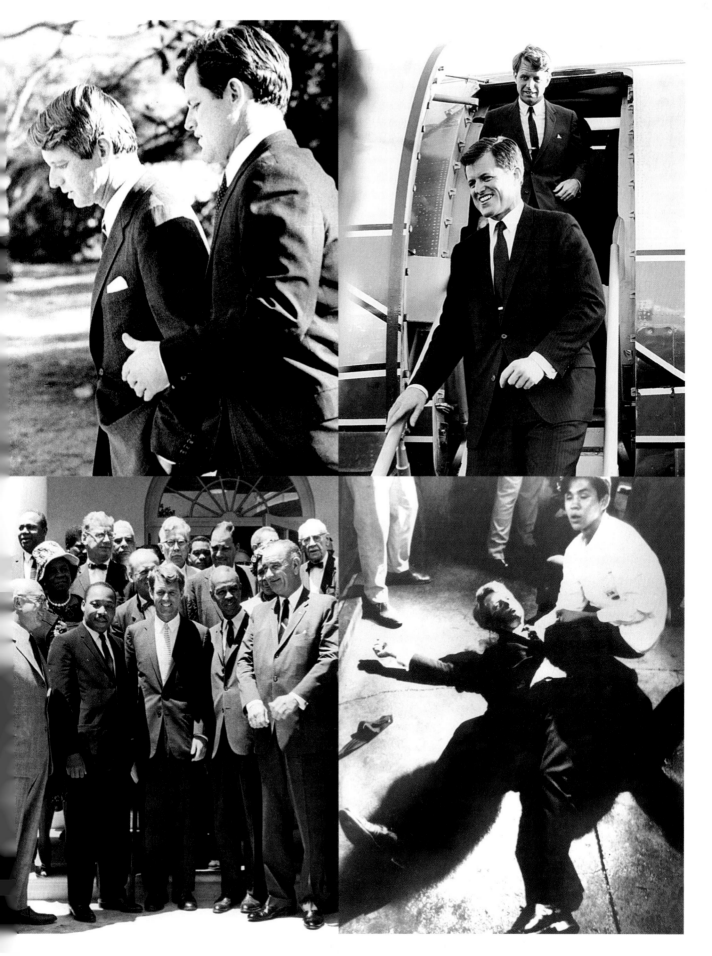

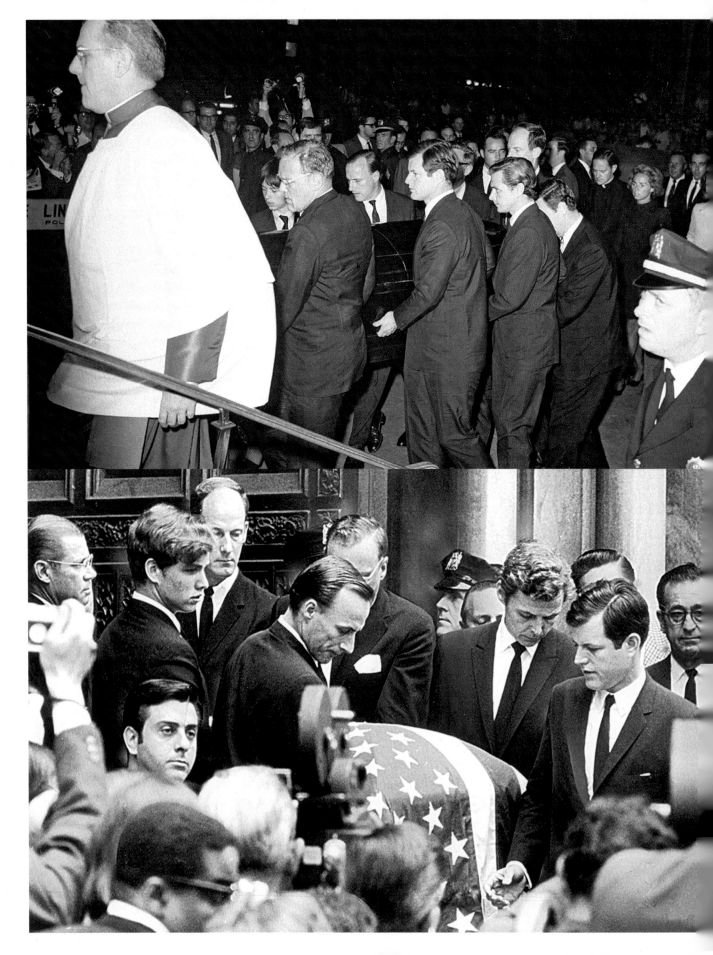

Opposite (Top) Ted and his brother-in-law Stephen Smith (to
his right) help carry Bobby's casket into St. Patrick's Cathedral
in New York. (Bottom) After the funeral mass on June 8, the
pallbearers carry the casket out of the church.
Below Richard Nixon and Ted, seated behind Michigan Governor
George Romney, are among the mourners at the funeral of Martin
Luther King Jr. in Atlanta on April 9, 1968.

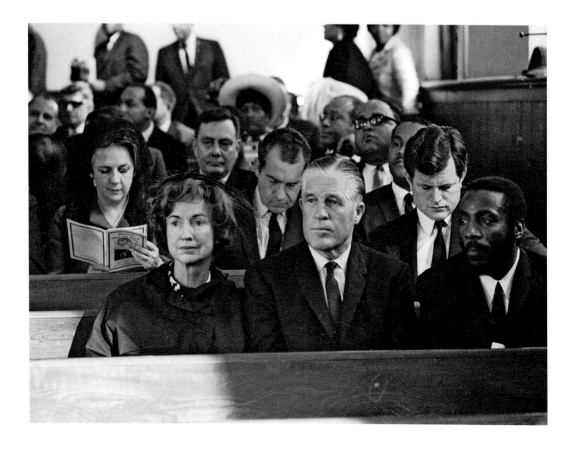

Chappaquiddick

"On July 18, 1969, at approximately 11:15 P.M. in Chappaquiddick, Martha's Vineyard, Massachusetts, I was driving my car on Main Street on my way to get the ferry back to Edgartown. I was unfamiliar with the road and turned right on Dike Road instead of bearing hard left on Main Street. After proceeding for approximately one-half mile on Dike Road, I descended a hill and came upon a narrow bridge. The car went off the side of the bridge. There was one passenger in the car with me, Miss Mary [a blank space followed. Edgartown Police Chief

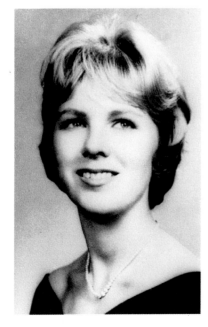

Dominick Arena said the senator did not know how to spell Kopechne's name], a former secretary of my brother Robert Kennedy. The car turned over and sank in the water and landed with the roof resting on the bottom. I attempted to open the door and window of the car but had no recollection of how I got out of the car. I came to the surface and then repeatedly dove down to the car and tried to see if the passenger was still in the car. I was unsuccessful in that attempt."

80

Opposite Salvaged at water's edge, the car in which Mary Jo Kopechne (above) died late on the night of July 18, 1969, after Senator Kennedy drove it off a bridge on Chappaquiddick island.

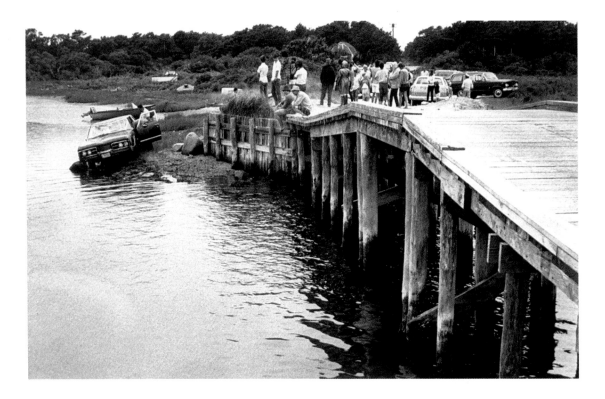

Ted Kennedy composed those words as part of an unsigned statement he reportedly gave to Chief Arena on July 19. Four decades later, serious questions remain about his and others' actions, and inactions, on the night of the fatal accident. Judicially, Kennedy pleaded guilty on July 25 to leaving the scene of an accident; he was given a two-month suspended sentence. In January 1970, an inquest was held in Edgartown, at which the judge took strong issue with several of Kennedy's assertions about what had happened, while concluding that "negligent driving appears to have contributed" to Kopechne's death.

A coincidental mix of news was recorded in Boston on July 20, 1969: The Chappaquiddick story shared front-page placement with the headline "All Is Go for Moon Landing Today," the latter announcing an event that would fulfill a goal boldly enunciated by President Kennedy eight years earlier.

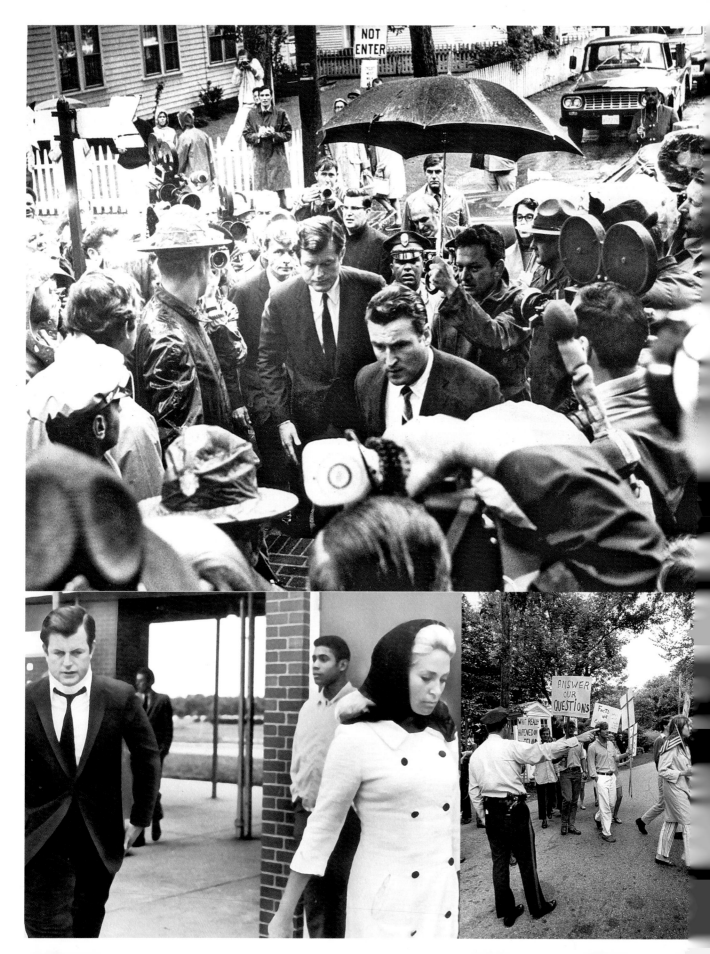

Opposite (Top) A downcast Senator Kennedy walks into the courthouse at Edgartown on July 25 for a judicial hearing at which he pleaded guilty to leaving the scene of the accident. (Bottom left) Joan leads the way out of the airport in Hyannis. (Bottom right) Demonstrators demanding answers to their questions about what happened at Chappaquiddick.
Below The senator's televised address to the citizens of Massachusetts, speaking about the accident and asking them to help him decide his political future.

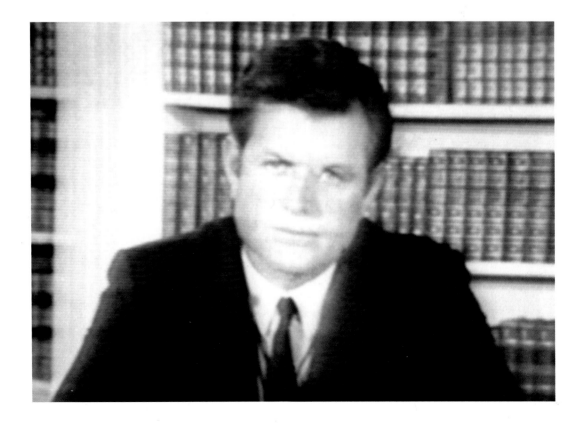

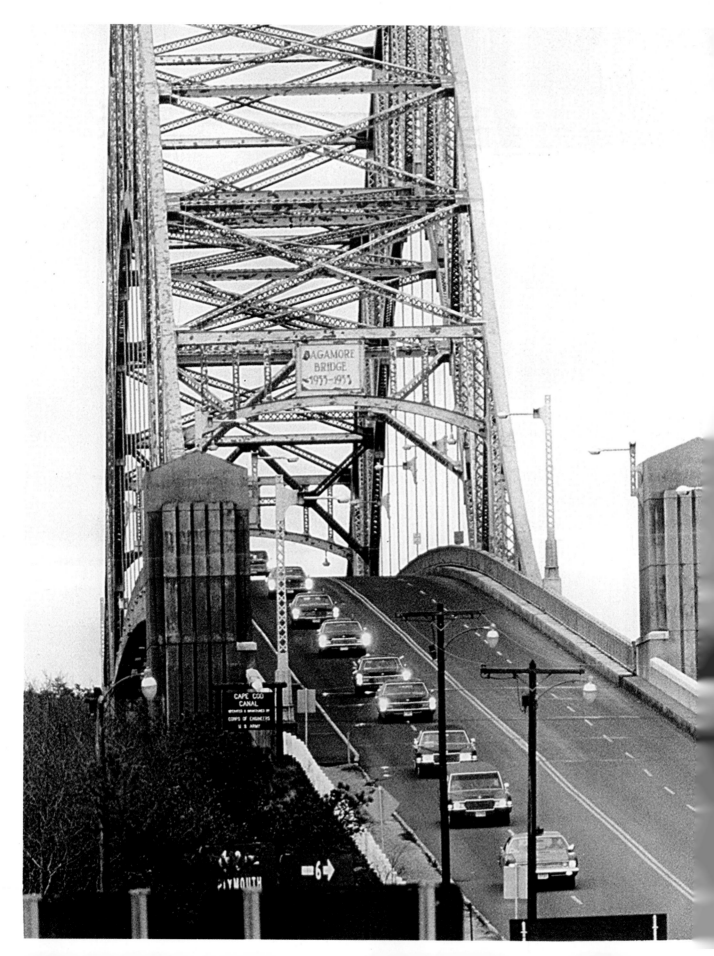

One last time: The patriarch of the Kennedy clan takes his final leave of Cape Cod as his funeral procession crosses the Sagamore Bridge onto the mainland on November 20, 1969.

Farewell, Papa Joe

He was an aggressive and enormously successful Irish-American businessman over the first six decades of the twentieth century, impatient with those who did not think or act with dispatch in the service of their goals. Joseph P. Kennedy Sr. had been the driving paternal force behind three of his boys as they had attained positions at the pinnacle of American public life. And he had watched helplessly as, one by one, four of his nine children—Joe Jr., Kathleen, Jack, and Bobby—died too young, the latter two by assassin's bullets. Fate allowed him a brief period to enjoy his second son's short time in the White House before Joe suffered a stroke that sapped his vigor and left him dependent on loved ones for the simplest things. And now, near the end of November 1969, he was dead at eighty-one, his long decline mercifully at an end.

Joe Kennedy had had a dream, not only for himself but also for his family. As the 1960s closed, that dream gave way to a shattered reality: Jack and Bobby had been murdered, and Teddy was struggling in the wake of a death at Chappaquiddick. But Ted was a Kennedy and he would go on, taking life and death as they came his way.

85

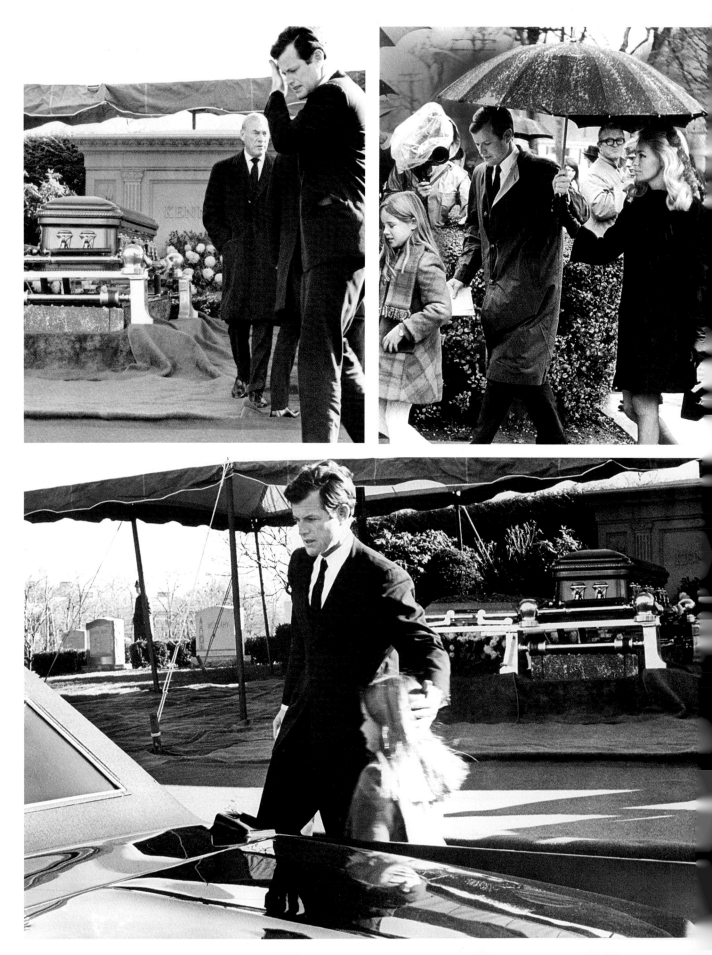

Opposite (Top left) Ted at his father's gravesite in Holyhood Cemetery, Brookline, Massachusetts. (Top right) Joan, Ted, and Kara enter the church in Hyannis for Papa Joe's funeral mass. (Bottom) Kara and her father leave the cemetery after the final graveside rites.

Below Joan, Ted, Teddy, and Kara on the beach in Hyannis Port the day before Papa Joe's funeral.

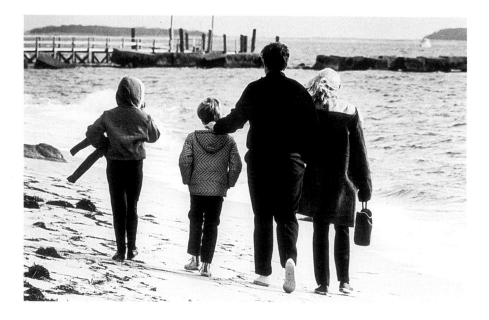

In the twelve years that I have been in the United States Senate I have voted for equal rights for all Americans. And I think I have had the overwhelming support of the people of Massachusetts and the people of Boston, and that we in Boston can't express one rule for Birmingham, Alabama, and another rule for Boston, Massachusetts.

—Ted Kennedy, September 9, 1974, supporting the desegregation of Boston's public schools after being jeered at a downtown rally against busing

The 1970s
Down but Not Out

The senator checks his notes before giving a speech on the situation in Cambodia, May 1970.

The 1970s were a time of reckoning for the senior senator from

Massachusetts. The repercussions from Chappaquiddick echoed down through the

years, beginning a week into 1970 with an inquest that moved Judge James A. Boyle

to conclude that Kennedy's account of what happened on the night Mary Jo Kopechne

drowned lacked credibility, though the judge, the Dukes County district attorney,

and a grand jury decided against acting on the findings that the defendant called

"unjustified." The tragic event at Chappaquiddick tugged at the senator's standing

as he buried himself in family commitments and legislative work in Washington, ran

twice for reelection, and, after years of deliberation, finally decided to reach for the

presidency.

He had asked the citizens of Massachusetts to let him know if they thought he should

run to keep his Senate seat in 1970, and their answer in November was resounding: a

nearly 487,000-vote win over his Republican opponent. Secure now in his position, Ted

turned to his responsibilities in Congress, where the Vietnam War, which he had opposed,

was now being waged under Richard M. Nixon. The war dominated the proceedings, but

matters important to the Democrat majority, and Kennedy in particular—health care,

civil rights, education, and other domestic considerations—were always on the table.

There was one setback, which proved to be minor as time went by: early in 1971, West

Virginia Senator Robert Byrd challenged and defeated Kennedy for the majority whip's

position that Ted had gained to widespread acclaim in 1969. At the time some saw the

Kennedy loss as a severe blow to his ambitions, but the senator later said he was a better

legislator for having been freed of the post's clerical duties.

Cruel fate, with its usual special attention to the Kennedys, intervened in 1973, when Ted and Joan learned that young Edward, then twelve years old, had developed a rare cancer in his right leg that could be halted only if the leg were surgically removed. The operation was successful, and the boy resumed a "normal" Kennedy life.

In 1974, the nation was roiled by political upheaval as the fallout from a break-in at Washington's Watergate complex in June 1972 was leading inexorably to the premature end of the Nixon years in the White House. Kennedy was, like all of Washington, deeply involved as the Congress and the country moved to deal with the scandal. In Boston, a federal judge had set in place his plan for the desegregation of the city's schools that would begin with the first day of classes in September. The image of the Puritans' city as a cultivated center of civic responsibility was remade by the explosive, violent reaction to the judge's orders, especially in South Boston. The senator soon found himself a target in white neighborhoods for his efforts to support the rule of law.

As Nixon's resignation led to Gerald Ford's interim presidency, the Democrats began to set their sights on retaking the White House. Would Ted Kennedy run in 1976? No, he answered emphatically the month after Nixon left for California. Those who knew him said his decision was based on commitments to family—Joan's shaky hold on her mental health and her struggles with alcohol, his son's continuing recovery from cancer—and the senator's sense that it was not the right time to run. The last of the Kennedy men had learned not to anticipate the future. But, in 1979, he surprised more than a few people when he changed course and decided to challenge an incumbent president of his own party for the 1980 presidential nomination.

Voice of the People

On August 27, 1970, Ted Kennedy, on his way to reelection, introduced a bill

in the Senate that addressed his top legislative priority: "We offer today a health

security program that will enable our nation to make the right to health care not

merely a principle or a social goal, but a living and functioning reality." Over the

next four decades, the issue was put regularly before the Congress and successive

presidents, always falling short of a law-making consensus. One proposal on the

Kennedy priority came from an unlikely quarter: In 1971, Richard Nixon suggested

expanding health care to nearly all Americans, with the federal government

subsidizing insurance premiums for the poor. But that wasn't enough for Kennedy;

he insisted on pushing for a system paid for through revenues and Social Security

taxes. Neither plan gained approval. Almost forty years later, the senator told *Boston

Globe* reporter Susan Milligan, "We should have jumped on that."

But there were other issues on the nation's docket that earned Kennedy's

attention—echoes from the New Deal, the New Frontier, and the Great Society.

These included arms control, support for the poor (Women, Infants, and Children

nutrition program), care for the elderly (Meals on Wheels), and equality for

women (Title IX legislation that barred gender discrimination at educational

institutions receiving federal support). In every significant debate on these and

92

other vital matters—Vietnam, the appointment of federal judges, Watergate and

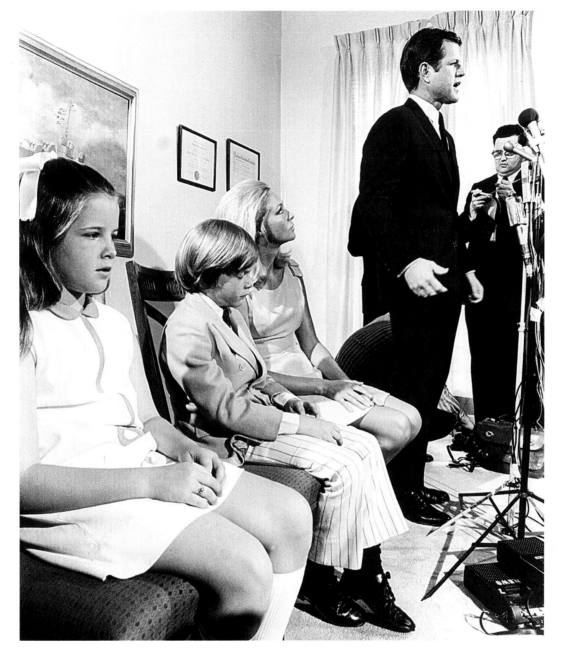

its aftermath—there was always one ringing voice that could be heard loud and clear, calling on the nation and fellow legislators to salute the values of the party of Franklin Roosevelt, Harry Truman, JFK, and LBJ.

Page 93 As Kara, Ted Jr., and Joan listen with varying attitudes of attention, the senator announces on June 11, 1970, that he will seek reelection to his Senate seat.

Below Joan and Ted make their way through a throng of well-wishers on the night of his reelection in November 1970.

Opposite (Top) The senator kicks off 1973 with yet another push for a national health care plan. A fan reaches out to him after his speech on the issue at a meeting in Boston's Grove Hall section. (Bottom) Keeping after the cause at the National Governors' Conference, August 1978.

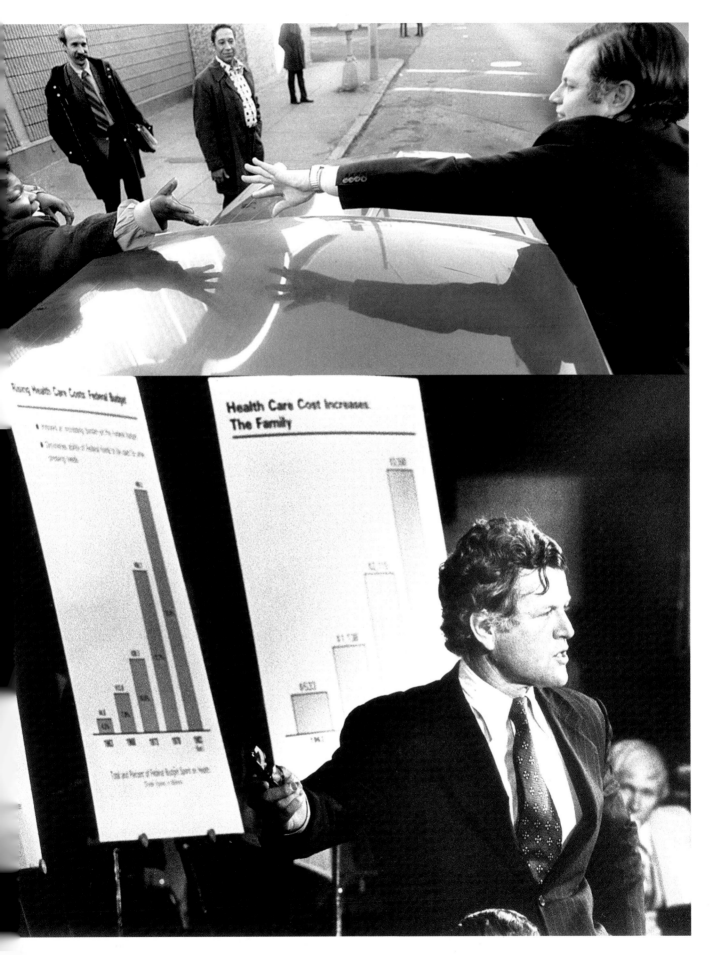

Health Care Hits Home

In November 1973, Edward Moore Kennedy Jr., known in his family as Teddy—the same nickname his father had answered to when he was a boy—was a seventh-grade student at St. Albans School in Washington, where he was a gritty athlete with an impish sense of humor. But one day early that month, he came home with a lumpy bruise on his right leg that worried his alert governess. Subsequent X-rays and other medical tests revealed the worst: there was cancer in the leg. His parents were told it would have to be amputated above the knee.

The bad news was closely held, even from young Teddy, as his father consulted with specialists. "They couldn't give Ted and me a good prognosis, or a prognosis at all," said Joan, "because they just didn't know." In a tearful discussion the day before the operation, Ted finally told his son what he was facing. As it turned out, the slow-moving cancer, called chondrosarcoma, was not in the bone, as originally suspected, but in the cartilage. At Ted's urging, the doctors treated the case aggressively. For the next two years, Teddy was taken out of school every few weeks by one or both of his parents to undergo a daylong series of intravenous therapy and injections. By the spring of 1974, the young patient was well on his way back to relatively good health.

96

In March 1974, four months after surgery to remove his cancerous right leg, Ted Jr. enjoyed a basketball session with Boston Celtics star JoJo White and the team's coaching legend, Red Auerbach.

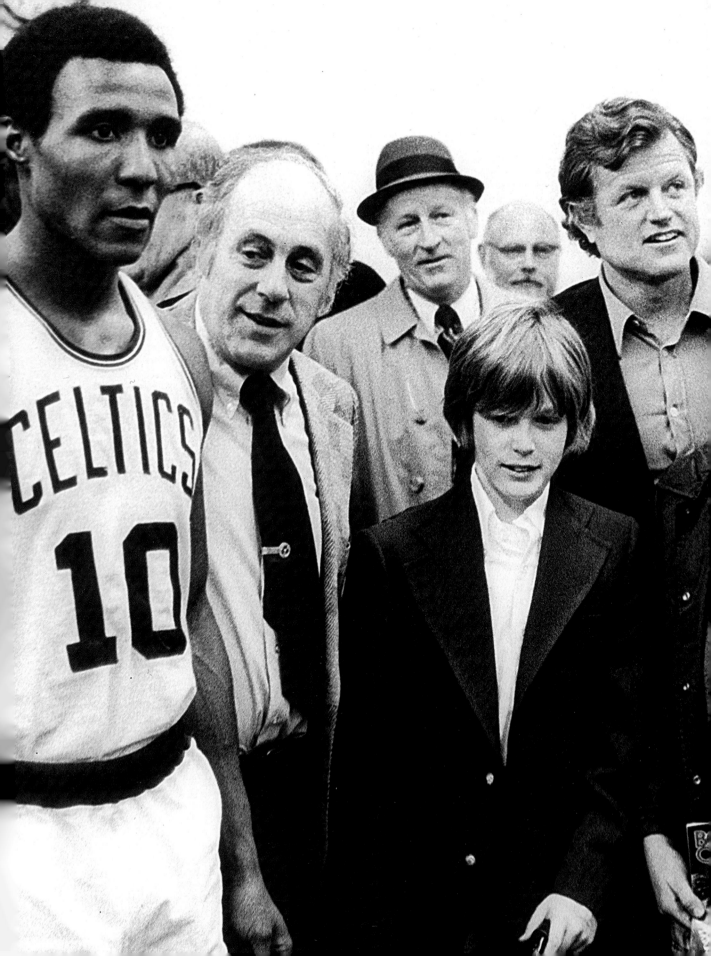

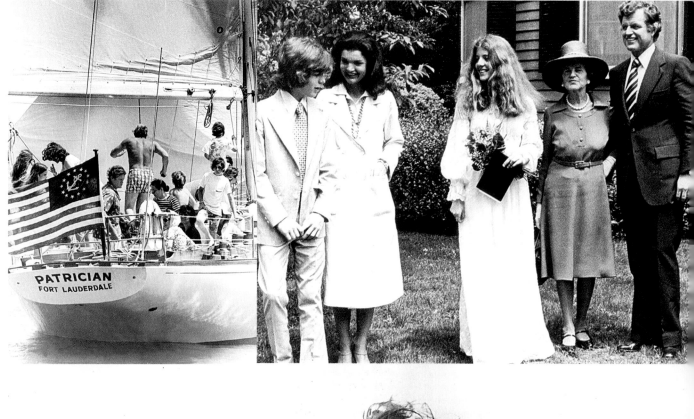

Opposite (Top left) The senator and family navigate the waters of Cape Cod in 1972. (Top right) Ted, Rose, Jackie, and John F. Kennedy Jr. join Caroline in celebrating her 1975 graduation from Concord Academy. (Bottom) Ted and Patrick thrill to the plunge of the Wildcat ride at Riverside Park in Agawam, Massachusetts, in July 1976.
Below Ted and Teddy at Harvard Stadium as the Crimson loses one, October 1979.

Tension in the Hub

On September 9, 1974, Senator Edward M. Kennedy walked into a restive,
angry crowd that had gathered in the middle of downtown Boston to protest the
impending busing of public school students away from their neighborhoods. Busing
was a key element of a desegregation plan being set in motion that week by U.S.
District Judge W. Arthur Garrity, with repercussions that would weigh on the
city for many years to come. The senator, who had stopped by to speak about the
responsibility of every citizen to follow the law, was stunned at his reception. Unable
to address the agitated protesters, he sought refuge by hurrying toward the John F.
Kennedy Federal Building a few hundred yards away while, as the *Globe* reported,
"angry mothers pursued him, pushing and shoving and flinging eggs and tomatoes."
From the safety of the building, Kennedy stated his position on the issue, a stance
he maintained thereafter: "I'm not for busing just for the sake of busing. . . . I'm

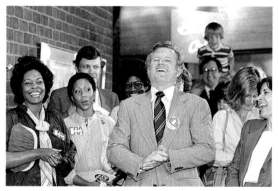

basically for quality education and safety
for the children."

Upheaval also marked life in
Washington that month as Gerald Ford
pardoned his predecessor, setting off
protests and giving Democrats a strong

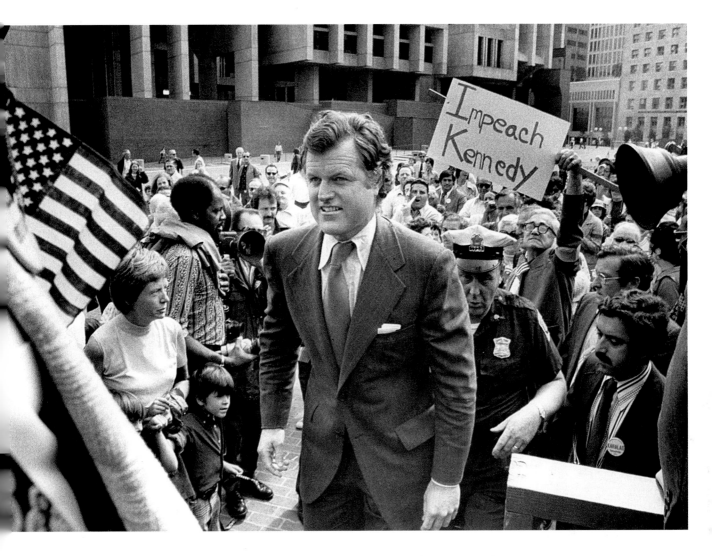

sense that the White House would be theirs in 1976. On September 23, citing what

he termed "apprehensions within my family about the possibility of my candidacy,"

Kennedy took himself out of the running, saying, "I will not accept the nomination.

I will not accept a draft."

Ahead was a successful reelection campaign in 1976 as Jimmy Carter won the

presidency, and continued close attention to legislation in the Senate, where Ted's

influence was now widely felt. In 1979, he assumed the chairmanship of the Senate

Judiciary Committee, a position of great influence in the selection of federal judges,

including those nominated to the Supreme Court.

101

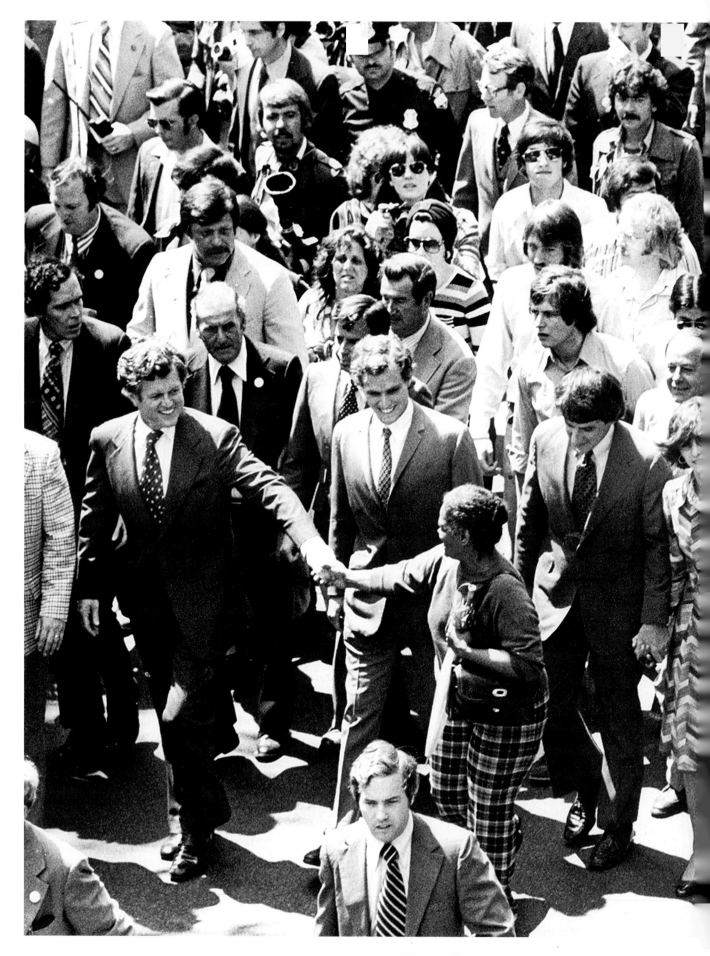

Page 100 The senator shares a laugh with members of the National Organization for Women, June 1979.

Page 101 Walking a gantlet of demonstrators and hecklers at an antibusing rally on Boston's City Hall Plaza, September 1974.

Left Senator Kennedy, far left, reaches out to a fellow peace marcher at a 1976 rally along Beacon Street in Boston. Marching in the same row with the senator were, from left: Joseph P. Kennedy II (Bobby's son), Massachusetts Lieutenant Governor Thomas P. O'Neill III, Kitty Dukakis, Bay State Governor Michael S. Dukakis, Kathryn White, and her husband, Kevin, the mayor of Boston.

EMK for President

While Jimmy Carter was settling in at the White House, Ted Kennedy was tending
to his knitting in Congress. But it became clear early on to observers with keen eyes
and ears that the senator's decision not to run for president in 1976 didn't apply to
1980. The economy had begun a slide into the red, and Kennedy was suggesting to
his confidants that Jimmy Carter was not the sort of Democrat the country needed.
By 1979, with inflation and interest rates at record high levels and the country in
what the president called a "crisis of confidence" over pocketbook issues such as

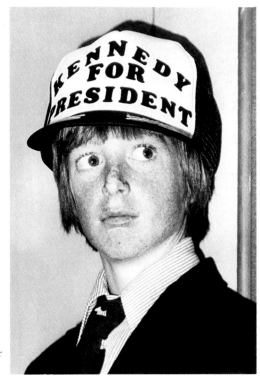

energy costs, Kennedy asked his supporters
to begin thinking about a presidential
run the following year, a risky proposition
against a sitting president of his own
party. Beyond that, there was a combative
Californian named Ronald Reagan waiting
in the wings on the Republican side.

There were uncomfortable moments
for Kennedy as his campaign began to
take shape. In late October, the president
came to Boston for the dedication of the
John F. Kennedy Library in the city's

104

Above Patrick Kennedy dons a campaign hat for his father's run for president.
Opposite (Top left) Using glasses reminiscent of his father's, Ted speaks at the 1979 dedication of the John F. Kennedy

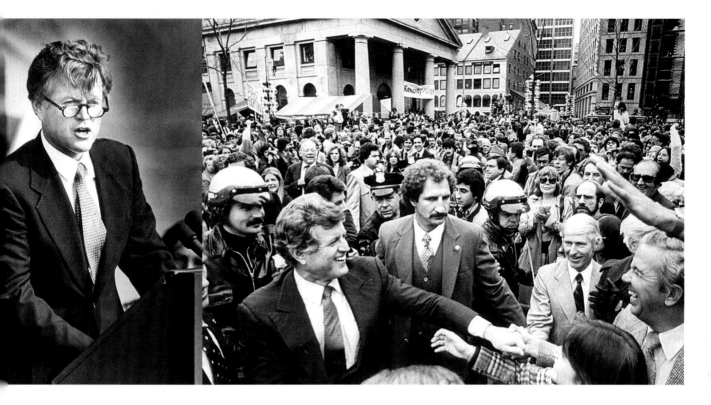

Dorchester section, during which Carter played his role with a grace that belied the strained relationship between the two Democrats. Then, on November 4, Iranian militants attacked the U.S. embassy in Tehran and took more than fifty hostages. The senator announced his candidacy three days later, echoing his late brother Jack's promise to get the country moving again.

The candidate had more than one strained relationship; Joan was living an unsteady life, drinking excessively and spending time in the hospital for "emotional strain" that many attributed to the stress of having a son with cancer and an inattentive husband who was always on the go. Ever the trouper, at least to that point, Joan sat quietly with her children as Ted made his announcement for president. She would help where she could in the campaign, but the signs were unmistakably clear: their marriage was on the rocks.

105

Presidential Library and Museum in Dorchester, Massachusetts. (Top right) Greeting supporters at Faneuil Hall Marketplace in Boston on November 7, 1979, after announcing he would run for president in 1980.

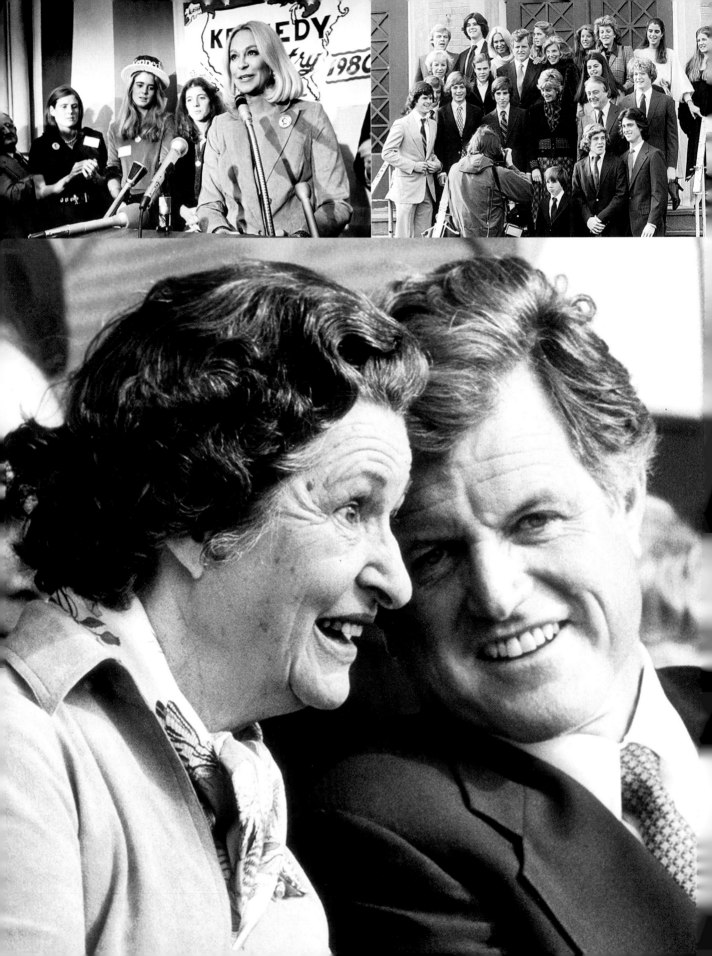

Opposite (Top left) Joan speaks at the opening of the Kennedy for President campaign headquarters in Boston on November 29, 1979. (Top right) *Globe* photographer George Rizer got the family to gather for a group picture on the steps of St. Christopher's on Dorchester's Columbia Point peninsula before the dedication of the John F. Kennedy Presidential Library and Museum. (Bottom) the senator shares a smile with Lyndon Johnson's widow, Lady Bird Johnson, at the dedication.
Below The airy inside pavilion of the library at left, and two outside views.

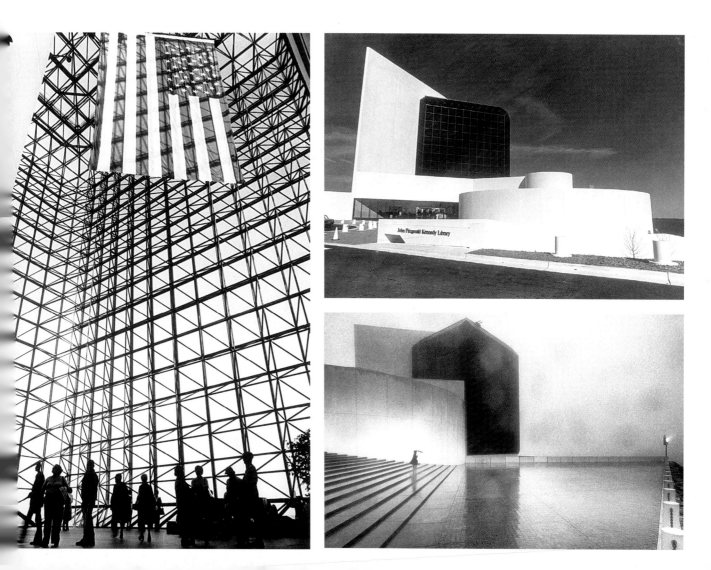

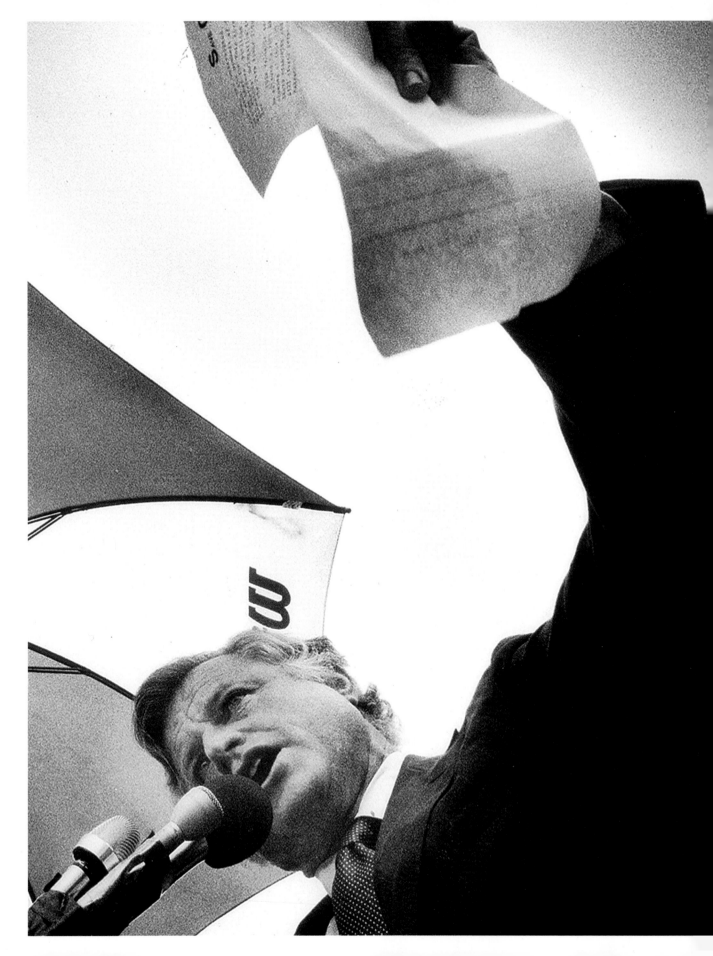

For me, a few hours ago, this campaign came to an end. For all those whose cares have been our concern, the work goes on, the cause endures, the hope still lives, and the dream shall never die.

—Ted Kennedy, speaking to the Democratic National Convention on August 12, 1980

The 1980s
Unleashing the Liberal Lion

Senator Kennedy speaks at a rally held to stave off the closing of the General Dynamics shipyard in Quincy, Massachusetts, August 1985.

On November 4, 1979, Ted Kennedy mostly muttered his way through a

nationally televised interview with CBS political reporter Roger Mudd, unable

to articulate clearly why he wanted to be president. Three days later, the senator

launched his only formal bid for the White House, taking aim at incumbent

president Jimmy Carter, who was already beset by a neurotic economy and by the

taking of fifty-two American hostages by Iranian militants in Tehran.

For the Democrats, the announcement signaled the beginning of a very public

yearlong squabble that would end up with both men emerging as decisive losers.

Though the president had a strong grip on the nomination going into the convention

in August, Kennedy did not concede a thing, withdrawing only after the first session.

The next day he gave the speech of his life, a clarion call for his party to hold onto

its values. His peroration was a personal commitment to the future, emphatically

punctuated with the memorable words "and the dream shall never die."

But parts of that dream would have to wait. A bruised Carter, faced with what he

called a "malaise" at home and the fate of the hostages in Iran, was no match for

the relentless drive of Ronald Reagan. For Ted Kennedy, Reagan's assumption of

the presidency in 1981 was a turning point; it was time to return again to the Senate

and work at keeping that dream alive, but probably not as president (in 1982 he said

no to 1984; in 1985 he said no to 1988). It was a task made all the harder because

in addition to taking the presidency, the Republicans had gained a majority in the

Senate. He was now a former chairman of that body's Judiciary Committee.

110

The day after the Reagan inauguration and the dramatic release of the fifty-two

hostages, Ted and Joan announced they were filing for divorce. The legal dissolution of their marriage was long in coming, but the couple avoided any pointing of fingers and issued a simple statement saying the time had come to part ways.

With the Republicans in the lead in the Senate, Ted Kennedy's ability to further his legislative priorities was crimped, but as he regained his legislative balance—and reelections in 1982 and 1988—he managed to gain consideration for some issues by joining with opposition senators and representatives in fashioning bills dealing with common concerns. He also traveled widely, to South America, Africa, Eastern Europe, and the Soviet Union, among other places, talking about human rights abuses, apartheid, and arms control. But it was at home where he was to make the loudest impact; at issue was a seat on the Supreme Court.

On July 1, 1987, President Reagan nominated a noted conservative, Federal Appeals Judge Robert H. Bork, to replace Justice Lewis Powell on the high court. Said Kennedy in a rapid response: "America is a better and freer nation than Robert Bork thinks. . . . His rigid ideology will tip the scales of justice against the kind of country America is and ought to be." That opening salvo by the leader of the anti-Bork forces was followed by two weeks of hearings and a Senate vote denying the judge a seat on the top court.

As the decade wound down, the senator had three electoral matters to keep his eyes on: his reelection campaign in 1988 (successful), the concurrent bid of Massachusetts governor Michael Dukakis for the presidency (unsuccessful), and son Patrick's run for a seat in the Rhode Island Legislature (successful). Ted Kennedy seemed to be in a comfortable place.

111

Reinventing the Dream

The Kennedy bid for president in 1980 got off to a rocky start in Iowa, where Carter received the votes of 59 percent of caucus delegates to the senator's 31 percent, and it stayed rocky through Carter wins in New Hampshire and Maine and on into the spring. It seemed that many voters couldn't get past Chappaquiddick. Even with late victories in New Jersey and California, the senator went to the Democratic National Convention in New York lacking the numbers to gain the nomination, so he conceded the win to Carter on the first day of the gathering. But it was his appearance at the convention, not Carter's, that became an electrifying event still talked about decades later.

Beaten but not bowed, the last of the Kennedy men delivered an oration that called on Democrats to affirm the effort that had defined their party's ideology for so many years—"the cause of the common man and the common woman." He said that there is a "guiding star in the American firmament" . . . and that "again and again, Democratic leaders have followed that star, and they have given new meaning to the old values of liberty and justice for all."

Kennedy clearly did not think Jimmy Carter was up to that affirmation. He was grudging in making up with the president-nominee at the convention, and less than spirited on the stump during the final months of Carter's campaign against Ronald Reagan.

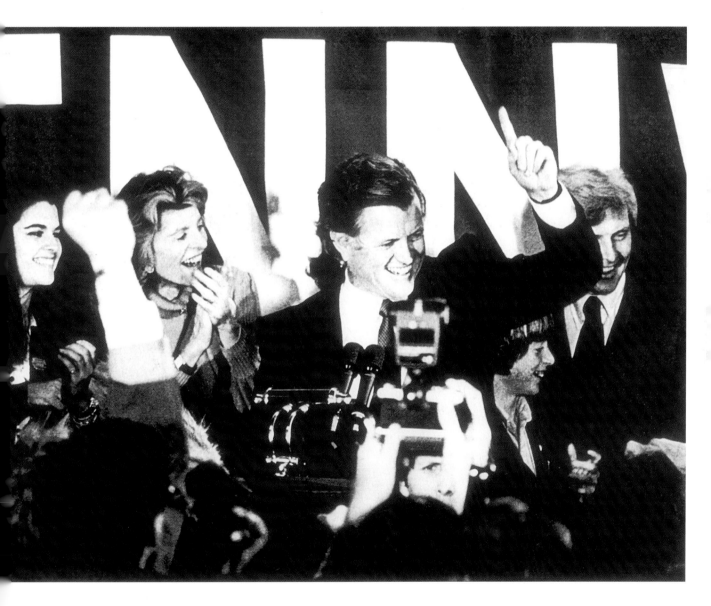

Calling on New Hampshire: During a trip north in February
1980, the senator asks Democrats in his neighboring state to
get on board his bandwagon.

Opposite After a full February day of campaigning in wintry Maine, a Kennedy worker snuggles in for a nap at the armory in Augusta.

Below (Top) The senator gives his memorable address to the Democratic National Convention on August 12, 1980. (Bottom) Two days later, showing something less than full enthusiasm, Kennedy joined Jimmy and Rosalynn Carter on the convention stage after the president had been renominated and delivered his acceptance speech.

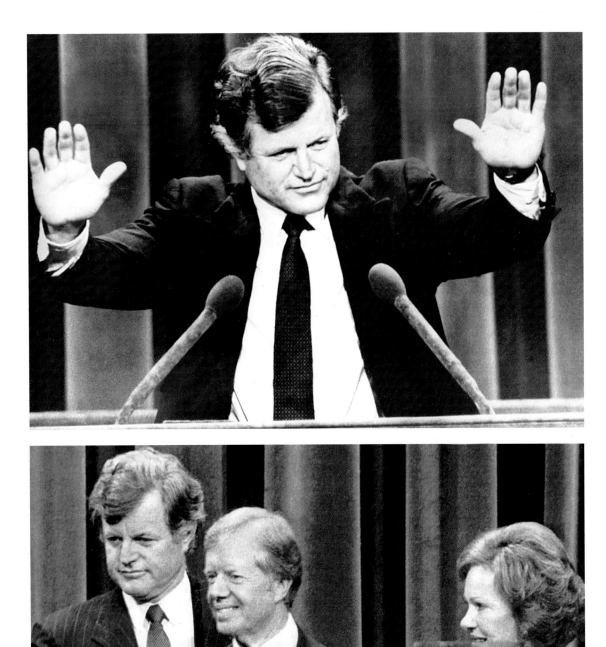

Moving On

"With regrets, yet with respect and consideration for each other, we have agreed to terminate our marriage. We have reached this decision together, with the understanding of our children and after pastoral counseling." So said Edward Moore Kennedy and Joan Bennett Kennedy in a statement issued on January 21, 1981, the day after Ronald Reagan's inauguration and the release of the American hostages by Iran shared headlines. The breakup of their twenty-two-year marriage came as no surprise to most observers. For the previous fifteen years or so, Ted was always on the go, politically and socially (at places like Chappaquiddick), most of the time without Joan, who had been receiving treatment for alcohol abuse and other problems.

Still, Joan had fought the fight in 1980 with her husband through the snows of Iowa and New Hampshire and on into the summer, attending rallies and speaking up for him as needed. She continued to share part of his dream, even when his dream no longer included the White House.

In 1982, the senator took himself out of competition for the '84 Democratic nomination; he had his reelection campaign to run that year, and no one was sure what effect his losing effort in 1980 would have at the ballot box in Massachusetts. Nothing negative, the voters decided; the final tally was Kennedy 60.8 percent, challenger Ray Shamie 38.3 percent. It was a bracing result; the senator knew where he stood with his constituents.

Play date: Kara and Patrick and their dad take in the action at a Boston
Bruins hockey game at Boston Garden, December 1982.

Below JFK Jr., Caroline, and Uncle Ted at the dedication of a park in Cambridge,
Massachusetts, honoring President Kennedy in May 1987.
Opposite A relaxed senator talks politics on the porch of his home in Hyannis Port
in August 1985.

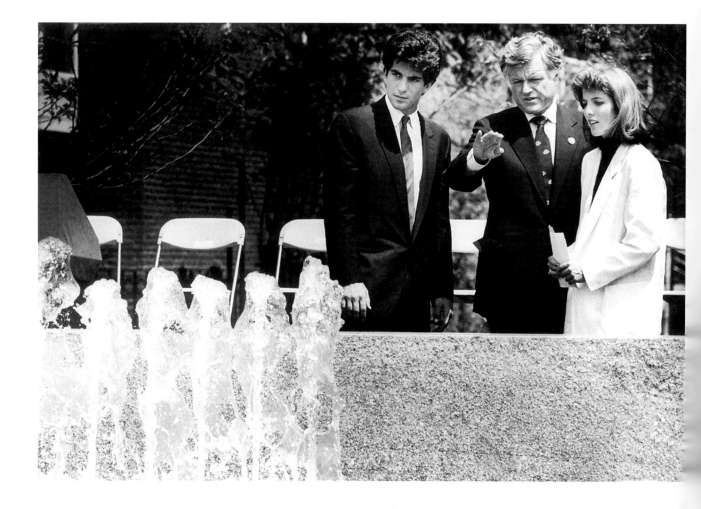

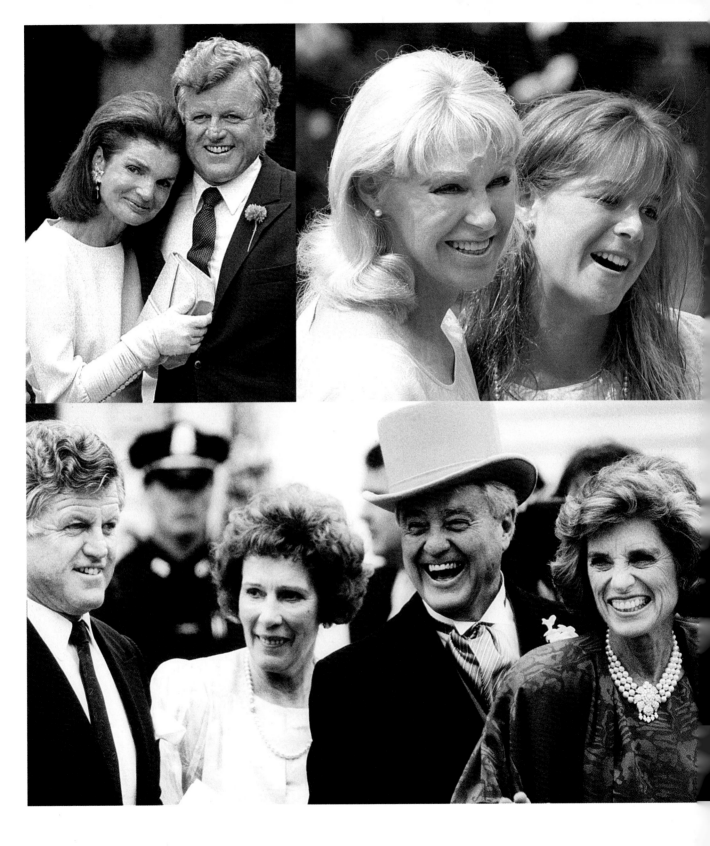

Opposite (Top left) The mother of the bride sheds a tear while hugging her brother-in-law. (Top right) Joan and Kara show their happiness for the bride and groom. (Bottom) A few months earlier, Ted celebrated the marriage of his niece Maria Shriver as she married actor (and future Republican governor of California) Arnold Schwarzenegger while the happy couple's parents looked on.

Below Caroline Kennedy, the princess of Camelot, took Edwin A. Schlossberg as her husband on July 19, 1986. Her Uncle Ted escorted her down the aisle.

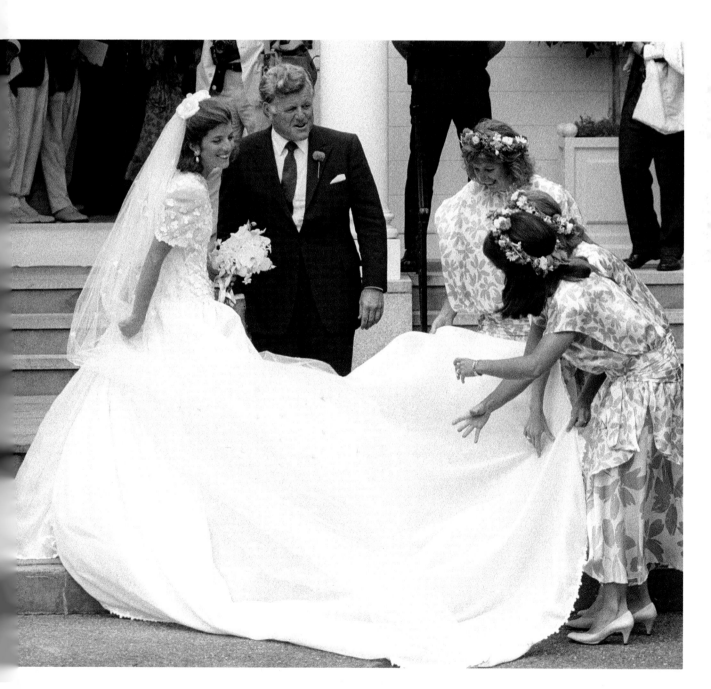

Tipping the Scales

Washington was an interesting political place in the 1980s. Republicans owned the White House and, from 1981 to 1987, the Senate. Democrats controlled the House, most of the time under another feisty Massachusetts political veteran, Thomas P. "Tip" O'Neill Jr. It took diplomacy to get laws enacted, and Ted Kennedy was a man practiced in balancing priorities and using persuasion to move bills along. His key domestic issues never changed—health care, civil rights, immigration, jobs—though he also invited controversy by speaking out on such topics as apartheid, abortion, deregulation, and arms control. He consistently found common cause with opposition members of the House and Senate, where over time his energy and diligence impressed key Republicans, including Utah's Orrin Hatch and Indiana's Richard Lugar, and even a future conservative vice president, Dan Quayle.

When Kennedy announced in 1985 that he would not run for president in 1988, many saw it as an unstated admission that his White House ambitions had been superseded by his sense of belonging and accomplishment in the Senate. He was given chairmanship of the Labor Committee, a platform for his dedication to jobs creation and equity in the workplace.

A nomination to the judiciary in July 1987 propelled him back into the center of the political world: Robert H. Bork was announced as Ronald Reagan's choice to fill a vacant seat on the Supreme Court, and one day later the senator spoke out loudly:

122

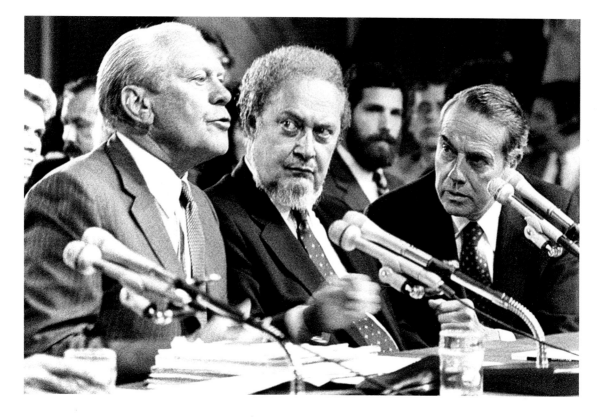

"Robert Bork's America is a land in which women would be forced into back-alley abortions, blacks would sit at segregated lunch counters, rogue police could break down citizens' doors in midnight raids, and schoolchildren could not be taught about evolution. Writers and artists would be censored at the whim of government, and the doors of the federal courts would be shut on the fingers of millions of citizens for whom the judiciary is—and is often the only—protector of the individual rights that are at the heart of our democracy."

Some took exception to Kennedy's assertions, but after several weeks of hearings and contentious give-and-take between Bork and members of the Judiciary Committee, the Senate voted to deny the president his choice. Bork was out.

123

Just say no: Former President Gerald R. Ford, Federal Appeals Court Judge Robert Bork, and U.S. Senator Bob Dole of Kansas at the U.S. Senate's Judiciary Committee hearing.

Harbor watch: In June 1987, Ted takes a ride aboard a Massachusetts Port Authority fireboat to assess the environment. Pollution in Boston Harbor and what to do about it had long been a contentious issue for the city and the state. In 1985, a total cleanup was mandated by Federal Court Judge A. David Mazzone.

Poverty watch: Continuing to push his priority issues, Senator
Kennedy addresses a 1987 conference in Boston on antipoverty
measures.

Like Father, Like Son

While he was running around the country stumping for Massachusetts governor and

1988 presidential nominee Michael Dukakis, who ultimately lost big to Vice President

George H. W. Bush, Ted Kennedy was himself campaigning for a fourth full term. As

in his previous five races, it was no contest when the votes were counted. With Kara

and Teddy pitching in, he took the measure of his Republican opponent, Joe Malone,

65 percent to 34 percent, and headed back to the Capitol.

While the two elder children opted out of politics after their experience in their

father's campaign, their brother Patrick, then twenty, stepped into the ring. A

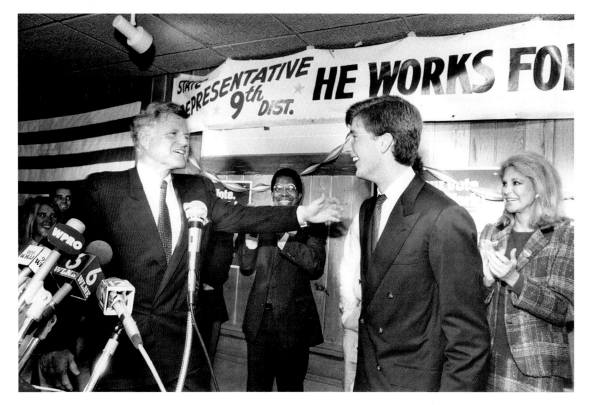

student at Providence College, he had been elected in early 1988 as a Dukakis

delegate from Rhode Island at the Democratic Convention. After having surgery

in April to remove a benign tumor on his upper spine, he decided to run for a seat

in the Rhode Island House against an incumbent Democrat. He campaigned in the

Kennedy manner, door-to-door, as family members, including veteran campaigner

Joan, joined up. He won the seat, beating his opponent by 315 votes in September.

The next Kennedy generation was in the game.

127

A win-win: Ted congratulates Patrick, a recent graduate of Providence
College, on the night in September 1988 when Patrick won a state
representative's seat in Rhode Island's Ninth District.

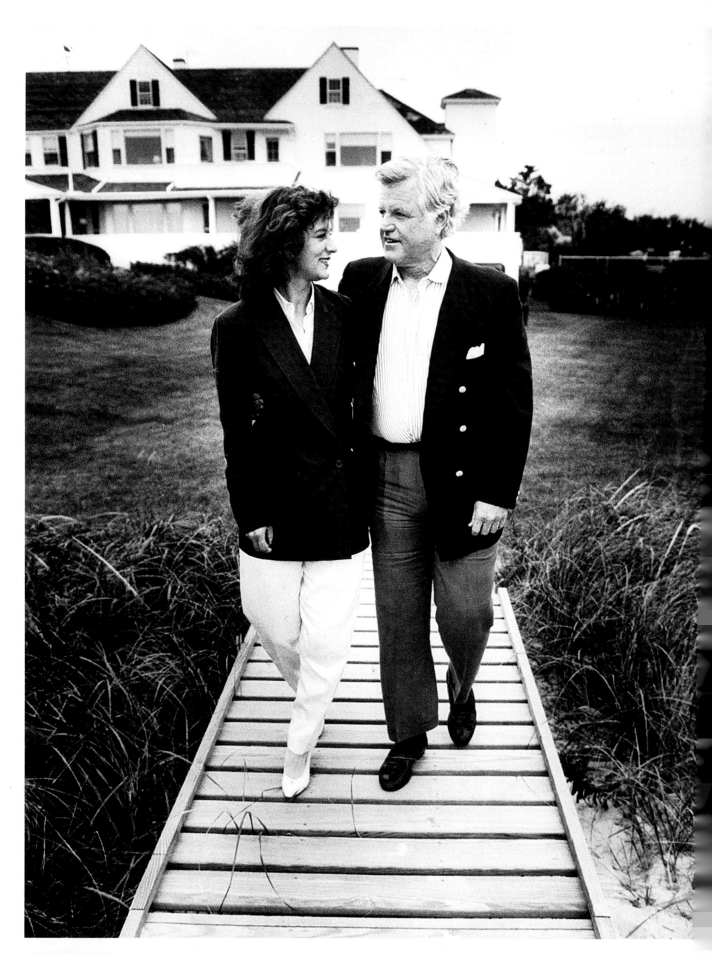

I decided I didn't want to live the rest of my life without her, and as the relationship developed, it brought a new kind of serenity, stability, and security that obviously has an impact on one's attitude and view of life. I think it makes you a better person.

—Newlywed Ted Kennedy, speaking about his marriage to Victoria Reggie, in an interview with the *Boston Globe* on September 8, 1992

The 1990s
Uncle Ted Meets His Match

Happy couple: Ted and Vicki at the Kennedy compound in
Hyannis Port, September 1992.

Well into the 1990s, Ted Kennedy, the man who held high the banner

of traditional Democratic ideals, showed another side of himself to patrons of the

bistros and party places in Washington and wherever else he found himself—that of

a carouser who respected few limits and rejected few drinks and whose lifestyle was

fodder for the press. It hadn't always been that way; until the 1970s, with Watergate

and the public philandering of several prominent Washington politicians, the media

had never been comfortable tracking the nonpolitical comings and goings of their

politicians, especially those working the big stage in Washington.

But Ted Kennedy was always good copy, on the job or at play. Several incidents

at Capitol Hill restaurants resulted in embarrassing disclosures about Kennedy's

after-hours activities, and a late-night excursion with a son and a nephew to a bar

in Palm Beach dealt another severe blow to his and the family's reputation. For all

that, there were happier times: Teddy and Kara married and had children, and Ted

found himself enthralled with Victoria Reggie, a Washington attorney whose family

had long been friends with the Kennedys. He had found a match.

Back in the Senate, he was kept busy tending to large issues like the first Gulf

War and the dissolution of the Soviet Union, and lending his name and support

to significant legislation, including the Americans with Disabilities Act and a

host of bills dealing with community service, medical leave, mental health, crime,

immigration, and work and school opportunities.

And every six years, of course, he had a reelection campaign. In 1994 his

130

opponent was businessman Mitt Romney, whom he debated in a celebrated

encounter as polls showed that the race was uncommonly tight. Kennedy dominated the debate, and easily gained his sixth full term. And he would have family accompaniment in the next congressional session; Patrick had been elected to the U.S. House from Rhode Island.

But there were losses, too. In 1984, Bobby's son David, then twenty-eight, died in Palm Beach of a drug overdose; in August 1990, Steve Smith, sixty-two, husband of Jean Kennedy, died of cancer; in 1994, Jacqueline Kennedy Onassis died of lymphoma at age sixty-four; in January 1995, matriarch Rose breathed her last at her beloved Hyannis Port at age 104; in December 1997, another of Bobby's boys, Michael, thirty-nine, was killed in a skiing accident; and on July 16, 1999, John Fitzgerald Kennedy Jr., thirty-eight, and his wife, Carolyn Bessette, lost their lives when the small plane he was piloting crashed into the waters off Martha's Vineyard.

Untimely death had been part of Ted Kennedy's life since he was twelve years old and learned that his brother Joe had been killed in World War II. Now in his sixties, he was still mourning unexpected losses and, as patriarch of the clan, time and again offering eloquent eulogies of the departed. One of those eulogies was about a Kennedy and a Fitzgerald who was given a century and then some to make her mark in life. Speaking in St. Stephen's in Boston, Ted talked about his mother, Rose: "She sustained us in the saddest times—by her faith in God, which was the greatest gift she gave us—and by the strength of her character, which was a combination of the sweetest gentleness and the most tempered steel."

Man Overboard

An incident at La Brasserie, a restaurant on Capitol Hill, in 1985 captured well
the after-hours side of Ted Kennedy that played out into the 1990s. He and Senator
Christopher Dodd allegedly grabbed at and tossed around a waitress in a private
room before she fled the premises. No charges were ever brought, but the story itself
came to symbolize a vexing hypocrisy: Kennedy, the legendary tribune of civil rights,
didn't always practice what he preached.

Late on the Friday night of Easter weekend in 1991, that darker side of Kennedy
life hit home when Ted, his son Patrick, and his nephew William Smith, went out for
drinks in Palm Beach at a club named Au Bar. There they met Patricia Bowman, a
young single mother, and Michele Cassone, a waitress. Both women made their way
back to the estate around 3:30 A.M. Bowman and Smith walked to the beach. Police

charged later that Smith had tackled Bowman and
raped her, which he denied. The trial was nationally
televised, with the senator himself a star witness,
and Smith was acquitted five days later.

Kennedy recognized that such stories were the
stuff of defeat for a politician, even a Kennedy,
and in October he said as much in a speech he
gave at the John F. Kennedy School of Government
at Harvard: "I am painfully aware that the

132

On the case: Congressman Joseph P. Kennedy II and Senator Kennedy talk about the rape accusations against William Kennedy Smith (inset page 132), April 1991.

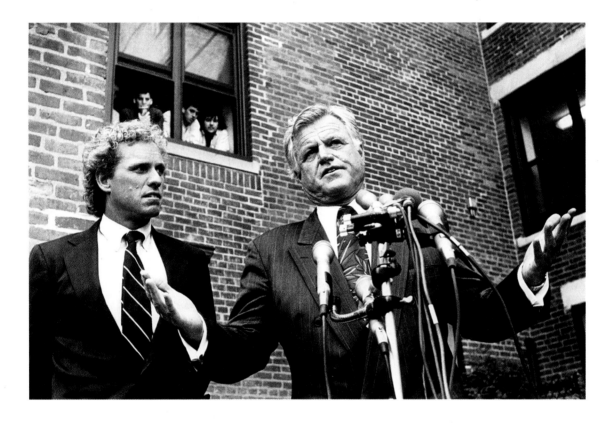

criticism directed at me in recent months involves far more than disagreements with my positions or the usual criticism from the far right. It also involves the disappointment of friends and many others who rely on me to fight the good fight. To them I say, I recognize my own shortcomings—the faults in the conduct of my private life. I realize that I alone am responsible for them, and I am the one who must confront them."

He would do so with Vicki Reggie at his side.

133

Life with Vicki

In June 1991, Senator Kennedy joined a party celebrating the fortieth wedding anniversary of Edmund and Doris Reggie of Louisiana. A retired banker and judge, Edmund had helped corral Louisiana Democrats into supporting Jack Kennedy in his bid for the vice presidential nomination in 1956 and in the presidential campaign four years later. He also worked on behalf of Bobby in 1968 and Ted in 1980, when Doris cast the only floor vote for Ted at the Democratic Convention.

The party took place at the Georgetown home of Vicki Reggie, a D.C. lawyer and second oldest of the Reggies' six children. Some two decades younger than Kennedy, she had once interned at his Capitol offices, where they shared only a brief conversation and a photo op. Married and divorced, with two children, five and nine years old, Reggie was at thirty-eight "a real star," said the managing partner at her law office, noting her intelligence and political acumen. When this five-foot-eight woman with hazel eyes answered the door to welcome the senator to the party, he was transfixed. This was a woman he needed to get to know, and he did. Ted and Vicki were married in a civil ceremony in July 1992 at the bridegroom's house in Virginia.

Two years later and just a month apart, Kara and her husband, Michael Allen, and Teddy and his wife, Katherine Gershman, added to the clan, introducing Kiley Elizabeth Kennedy in August 1994, and Grace Kennedy Allen the next month. There was more to come: Max Greathouse Allen in December 1996, and Edward Moore Kennedy III in February 1998.

134

Betrothed: The senator and his fiancée share a private moment a few months before their 1992 wedding.

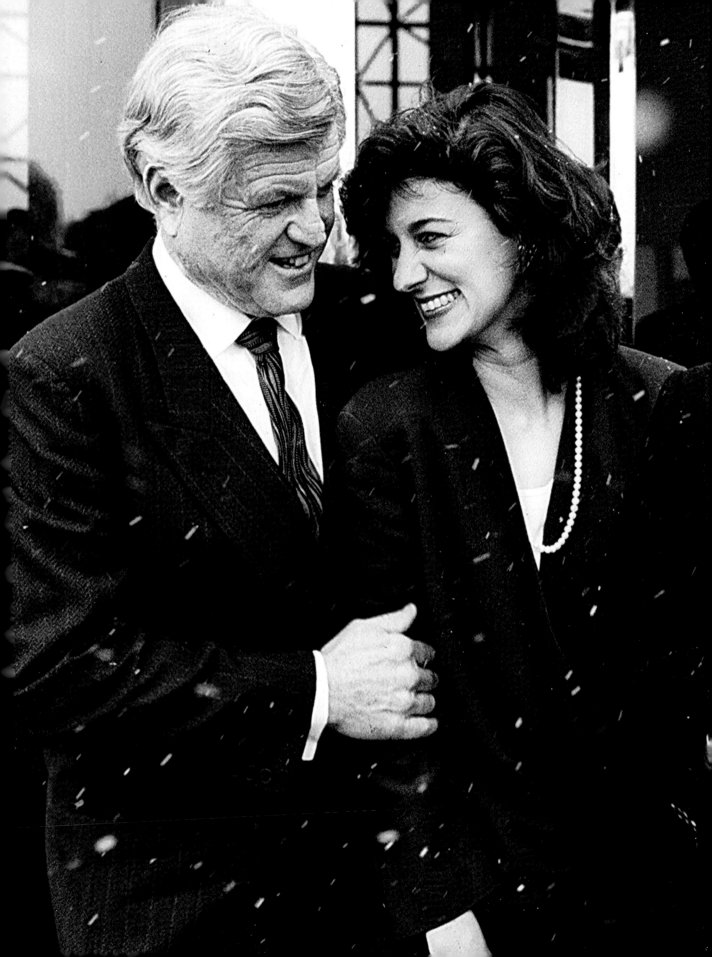

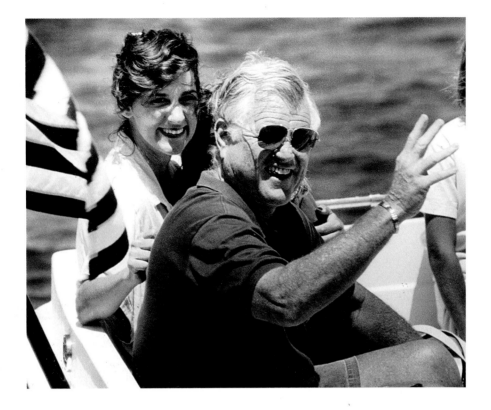

Above Newlyweds Ted and Vicki go for a sail, July 1992.
Opposite (Top) A beaming Kara Kennedy and her husband, Michael Allen, on their wedding day, September 1990.
(Bottom) Ted and Vicki, with her children, Curran and Caroline, head for the voting booth in Hyannis, November 1992.

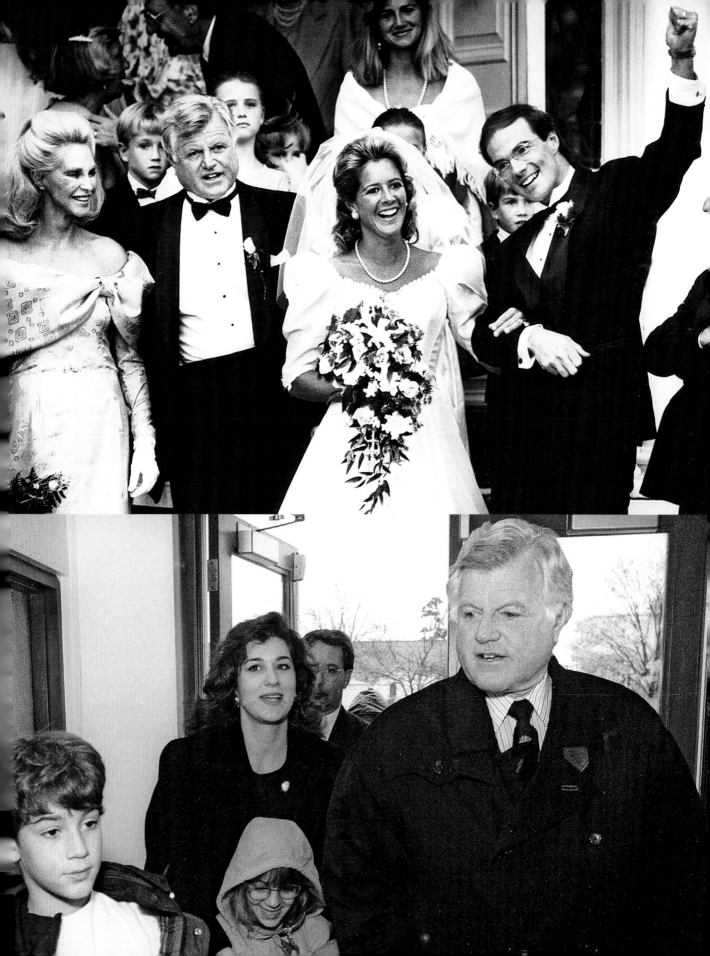

Three Teds: The senator, Ted Jr., and Ted III at Hyannis Port in July 1998.

Bring It On

Somehow Ted Kennedy was able to work at everything at the same time. While wooing and then marrying Vicki Reggie, he kept up the pace in Congress as the Reagan-Bush years gave way to an ebullient Arkansas governor named Bill Clinton. Using his ability to work across the aisle, especially with his friend and sometimes personal counselor Orrin Hatch, Kennedy introduced or managed a remarkable package of legislation in the 1990s, considering that Republicans had the majority for the last half of the decade. There was the landmark Americans with Disabilities Act, the Ryan White CARE Act, the Family and Medical Leave Act, the School-to-Work Opportunities Act, and tough legislation aimed at curbing crime. Not to say that he neglected foreign affairs. On a matter of great importance to the Kennedys, the violence in Northern Ireland, the senator was a key supporter of the lengthy process that led to the Easter peace accord in 1998.

By the end of summer 1994, polls showed him neck-and-neck with businessman Mitt Romney, who at age forty-seven was a wealthy man with a trim physique and a campaign wallet swollen by efficient fund-raising.

It was a midterm election, and the Republicans were expected to take back the Senate and possibly the House. Romney ran ads promoting his wholesome-looking family; Kennedy ran spots touting all he'd done for Massachusetts. Finally, in late October, the contenders met to debate in Boston's historic Faneuil Hall, and Kennedy quickly demonstrated that he still had fire in his belly. When Romney

Another yes vote: Ted, reelected in November 1994 after a bruising joust
with Republican Mitt Romney, shares a positive poster with the press.

suggested that Kennedy had profited from a deal with Mayor Marion Barry in
Washington, the senator shot back: "Mr. Romney, the Kennedys are not in public
service to make money. We have paid too high a price for that commitment."

Voters ultimately gave Kennedy an eighteen-point margin of victory. At the same
time, in Providence, Patrick won a seat in the U.S. House.

Opposite (Top) U.S. Senators Barbara Mikulski of Maryland, Barbara Boxer and Dianne Feinstein of California, Patty Murray of Washington, and Carol Moseley-Braun of Illinois signal their support for Ted Kennedy in his reelection bid as Vicki and the senator stand behind them in November of 1993. (Bottom left) In 1996, John Kerry joined his fellow Massachusetts senator to champion Internet access for the nation's schools. (Bottom right) Ted cultivated more fans in Salem, Massachusetts, during his 1994 reelection campaign.
Below Dressed in scrubs, the senator at a pharmaceutical firm's AIDS research laboratory, December 1990.

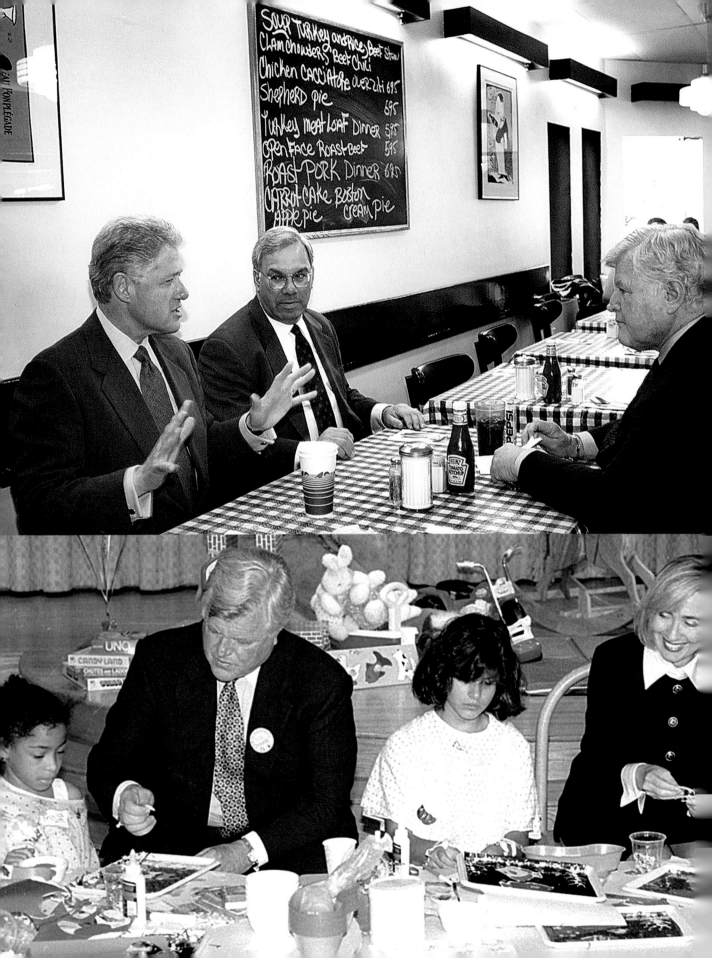

Opposite (Top) President Bill Clinton, Boston Mayor Tom Menino, and Senator Kennedy stop for lunch in the Hub. (Bottom) Hillary Rodham Clinton and the senator help with the art projects of some patients at Boston's Children's Hospital, September 1994.
Above (Top left) Mitt Romney debates Senator Kennedy in October 1994. (Top right) Joe Lane, a Massachusetts television salesman, finds himself in the middle of the discussion. (Bottom) Kennedy and Romney supporters jockey for position outside Boston's Faneuil Hall before the debate.

The Cruelest Cut

The good-byes came in waves across the decade. First Steve Smith, then Jackie, then Rose and Michael. In July 1999, came the national shocker: JFK Jr., his wife, Carolyn, and her sister Lauren Bessette were all dead, victims of a plane crash off Martha's Vineyard. In each case, it was left to Ted to gather their family and pay final respects in the Kennedy manner, which usually involved a eulogy by the oldest male member of the clan.

The loss of Jackie prompted Ted to reflect on good times and bad in his remarks: "She graced our history. And for those of us who knew and loved her, she graced our lives."

Of his mother, gone after 104 years, he said: "Mother always thought her children should strive for the highest place. But inside the family, with love and laughter, she knew how to put each of us in our place. She was ambitious not only for our success, but for our souls."

Remembering John Jr., his grief rang out again. Having buried JFK thirty-six years before, the senator was pained when he stood up to offer parting words to his nephew: "We thank the millions who have rained blossoms down on John's memory. He and his bride have gone to be with his mother and father, where there will never be an end to love. He was lost on that troubled night, but we will always wake for him, so that his time, which was not doubled, but cut in half, will live forever in our memory, and in our beguiled and broken hearts."

Page 147 (Top) The hearse carrying Rose Kennedy from Hyannis Port to St. Stephen's in Boston's North End, then on to Holyhood Cemetery in Brookline. (Bottom) The media in Hyannis Port for the wake of Bobby's son Michael.
Opposite Ted and Vicki leave a New York memorial service for JFK Jr.
Below (Top left) JFK Jr. eulogizes his grandmother and (top right) joins Caroline in escorting their mother's casket.
(Bottom) A memorial display for JFK Jr. at Boston's John F. Kennedy Presidential Library and Museum.

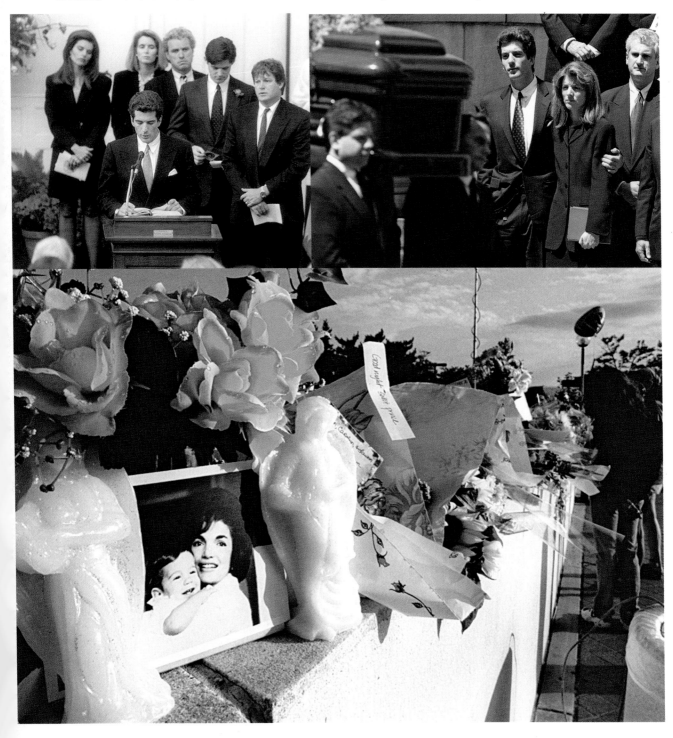

Above (Left) In happier times, Uncle Ted sat with nephews Michael and John and son Patrick at the State House in
Massachusetts in 1992. (Right) JFK Jr. on the pier at the Kennedy compound after a day of sailing in 1997.
Opposite The senator, his mother, and Ted Jr. at the compound in Hyannis Port, 1995.

Opposite JFK Jr. and his wife, Carolyn, visit the John F. Kennedy Presidential Library and Museum to commemorate the eightieth anniversary of John F. Kennedy's birth.
Below (Top left and right) Ted joins the search for JFK Jr.'s plane in July 1999. (Bottom) Kennedy cousins, led by Patrick and Ted Jr., escort a temporary casket.

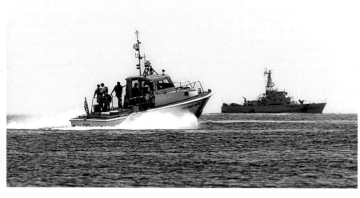

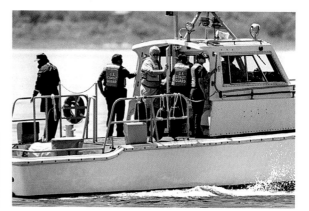

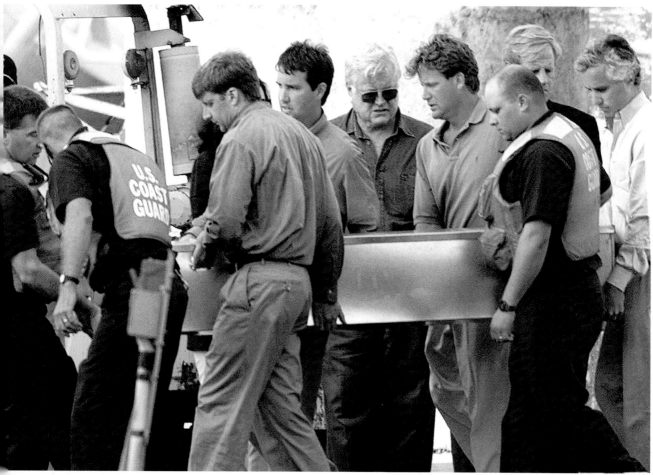

As I look ahead, I am strengthened by family and friendship. So many of you have been with me in the happiest and the hardest days. Together we have known success and setbacks, victory and defeat. But we have never lost our belief that we are all called to a better country and a newer world.

—Ted Kennedy, speaking to the Democratic National Convention on August 26, 2008

Twenty-first Century
The Lion in Winter

The senator at seventy-four: Waiting his turn to speak at the
John F. Kennedy Presidential Library and Museum, June 2006.

For Ted Kennedy, life in the dawn of a new century followed a familiar

pattern. In the Senate, he worked at making laws that tracked the priorities he had

been championing for forty years. At home, he was the father, grandfather, brother,

and uncle that the Kennedy clan turned to, as well as the chief mourner at the

funerals of his sisters Rosemary and Patricia. He tended to Kara and Joan during

their battles with cancer (lung and breast, respectively). And, in the face of yet

another national tragedy, he tended to his neighbors who were hurting as well.

The terrorist attacks on September 11, 2001, caused every American to take notice

that the twnty-first century had given the nation a newly emboldened enemy. When

a shocked Congress essentially gave President Bush and his team the go-ahead to

do what they thought it would take to defeat militant Mideast terrorist Osama bin

Laden and his Al Qaeda cohorts, Senator Kennedy was in tune with the spirit of

the reaction. But over time he found reason to oppose the president's decisions,

especially the military response that wandered from Afghanistan into Iraq without

what Kennedy considered adequate cause. One of twenty-three senators who voted

against the October 10, 2002, resolution granting Bush the authority to invade

Iraq, Kennedy spoke out on the Senate floor: "The power to declare war is the most

solemn responsibility given to Congress by the Constitution. We must not delegate

that responsibility to the president in advance." But Iraq was invaded, and the

predicted quick victory and quick withdrawal failed to materialize.

In Massachusetts, the senator was quick to reach out to his constituents who had

156 lost loved ones in the events of 9/11, personally contacting all 202 families to hear

their stories. From then on, he kept track of things by letter, by phone, and in person as they worked to get past their losses.

While the war pressed on in the Middle East, there were campaigns to be won (his reelection in 2006) and lost (John Kerry's narrow defeat at George W. Bush's hands), and work to be done on the never-ending flow of issues that keeps Washington in business.

Then, suddenly, it was Ted's turn to be cared for. In 2007 he had surgery for a blocked carotid artery, and in 2008, after a seizure sent him to the hospital, doctors found a malignant tumor in his brain. An operation and treatments including chemotherapy followed.

But even as he dealt with cancer, Ted Kennedy, in his late seventies, was still a redoubtable personal force. Leaving his sickbed, he made a dramatic trip to the capital to cast his vote on an important Medicare bill and in August he gave a stem-winder of an address at the Democratic National Convention in Denver.

Lions don't forget how to roar. As he entered the winter of life, Ted Kennedy could look back at an astonishing record of achievement in the Senate, all accomplished while he was attending to the high points and low points that came with being a Kennedy in the public eye. By 2008, according to his office, some 2,500 bills had been proposed under his direction, and more than 300 of them had become law, as had 550 bills that he cosponsored. Those numbers are but one measure of a man and senator who fought the good fight as he saw it, sometimes against overwhelming odds, and who, domestically and politically, kept the faith of his fathers.

Common Ground

As he moved into a new millennium with his contract renewed for the sixth time by the citizens of Massachusetts, Ted Kennedy was the same old workhorse, working to enhance the prospects of his favored issues, among them health care, education, immigration and a Democratic perennial, the status of the minimum wage. For a Patients' Bill of Rights proposal he teamed up with John Edwards and John McCain to get the legislation passed in the Senate. Then, in a rare political event, he found common cause with George W. Bush in the push to enact the landmark No Child Left Behind bill, a priority of the president.

It took just a year from the time the two men discussed the bill until it passed to much acclaim in 2002, but soon the senator began criticizing the administration for not fully funding the initiative. By 2003, Kennedy was saying that Bush had betrayed him by short-changing the program by $9 billion. He said Bush had looked him "straight in the eye" during negotiations and promised to fund it up to the ceiling Congress had approved. The White House argued back that even with the high costs of fighting terrorists, it was spending record amounts of money on education reform.

The bloom was off the rose of the Bush-Kennedy connection. Although later they would push for comprehensive reform of the country's immigration policy, that bill failed to gain passage in the Senate.

158

Sharing a guffaw with President George W. Bush at the Boston
Latin School, January 2002.

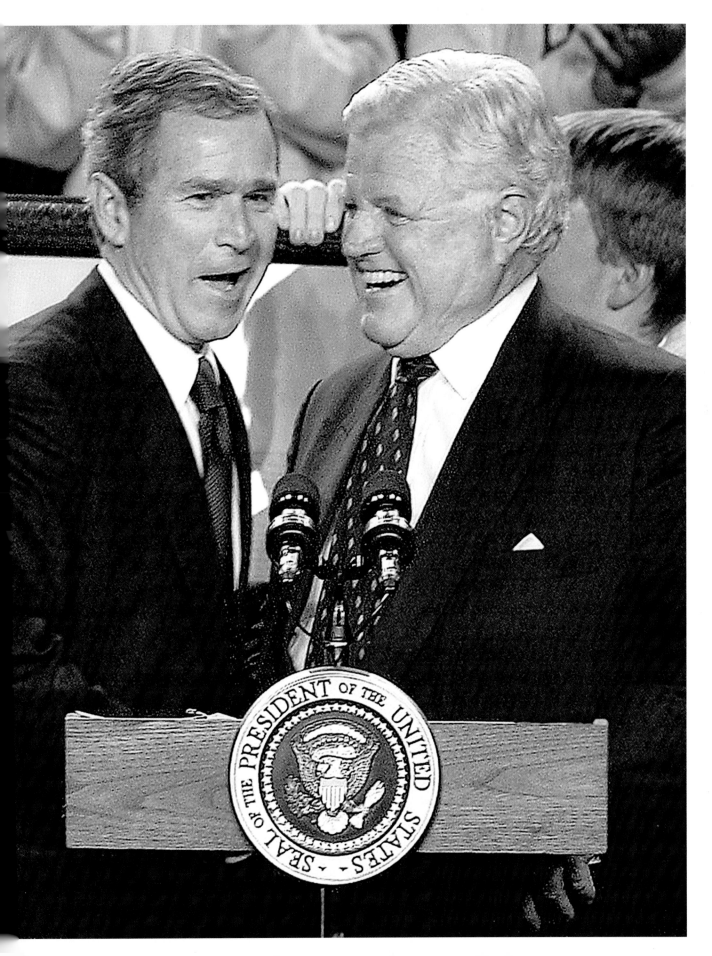

Opposite (Top) Yet another meeting, yet another speech, this time at the Forsyth Institute in Boston, where the late Joseph P. Kennedy was honored and the senator was joined by Forsyth President Dr. Dominick DePaola and Boston Mayor Thomas M. Menino, December 2003. (Bottom) Speaking to reporters at the State House after the Massachusetts Supreme Judicial Court ruled in favor of gay marriage rights, February 2004. **Below** Checking in with his Portuguese water dog, Splash, in 2001.

Army of One

Senator Kennedy was a man always in motion when it came to dealing with the
domestic effects of the attacks on America. The story told to the *Boston Globe* by
Foxborough, Massachusetts, resident Cindy McGinty, widow of forty-two-year-old
World Trade Center worker Mike McGinty, is an illustration of the lengths Kennedy
went to console and help those in distress.

A month after talking to her during his initial round of calls, the senator
invited the mother of two to come to a meeting in his Boston office, where she
encountered dozens of similarly bereaved victims' relatives trying to make sense of
the bureaucracy created to work on the Victim Compensation Fund. It was the first

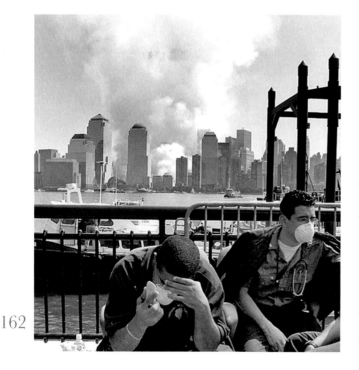

time any of the Massachusetts
survivor families had been
together. Sitting around the room
were representatives from the
FBI, the Red Cross, the Salvation
Army, the Social Security
Administration, the United Way,
and other governmental agencies
and nonprofit aid organizations.
McGinty summoned the courage
to chide them for requiring

162

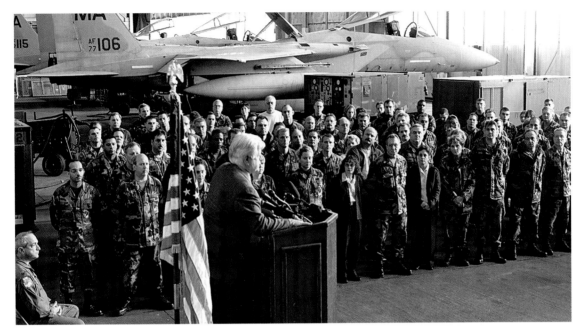

extensive documentation from survivors: "I'm a single mom with two kids. I can

barely get out of bed in the morning. I'm traumatized; my kids are traumatized.

Every one of you wants something from me. But you're making it too hard." A

startled Kennedy turned to an aide and said, "I don't want to ever hear that Mrs.

McGinty or one of the other families has this problem. Fix it!"

While Kennedy was orchestrating relief efforts like the one in his office, the

battle was on in Afghanistan as the United States moved to eliminate Osama bin

Laden's base of operations there. That effort had near universal support at home,

but the next move, an invasion of Iraq, was quite another thing for Kennedy. He

voted against a resolution giving Bush the power to unseat Saddam Hussein on

the pretext that the dictator was stockpiling weapons of mass destruction. As a

supposedly easy victory turned into a nightmare of civil strife in Baghdad and

beyond, the senator was heard describing Iraq as "Bush's Vietnam."

163

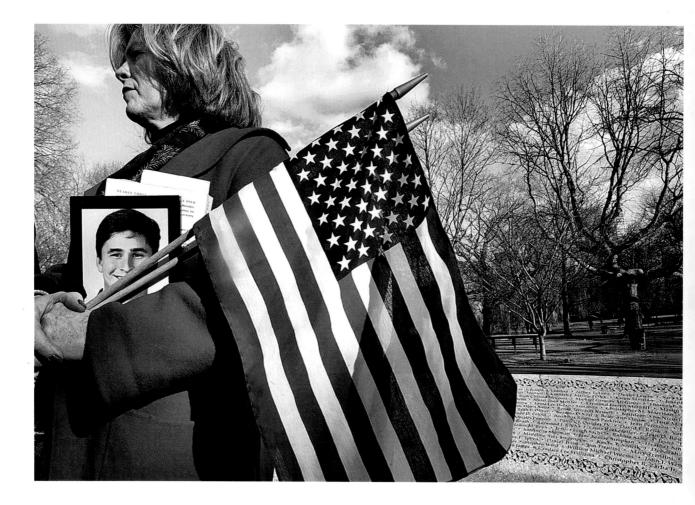

Page 162 New York City rescue workers take a break from the devastation, September 2001.

Page 163 Senator Kennedy salutes members of the Massachusetts Air and Army National Guard units for their work in New York City following the terrorist attacks of 9/11.

Above Mary Fetcher of New Canaan, Connecticut, who lost a son, joins other families at the Public Garden in Boston to urge Congress to adopt a rescue plan resolution. The families of 9/11 victims were of special concern to Senator Kennedy, who left nothing to chance when it came to helping them out.

Opposite The senator arrives at the memorial service in Dracut, Massachusetts, for John Ogonowski, the pilot of ill-fated American Airlines Flight 11.

On Broad Shoulders

As the survivors among Joe and Rose Kennedy's nine children and their generational relatives moved to the doorstep of old age, death and illness continued to take their toll. On January 7, 2005, Rosemary, the eldest of the Kennedy girls, died at eighty-six in a hospital in Wisconsin, where she had been institutionalized since the early 1940s. Later that same year, Joan Kennedy had surgery for breast cancer, and in September 2006, Patricia Kennedy Lawford, a gregarious woman who had brought the actor Peter Lawford into the family, passed away in a New York hospital from complications of pneumonia. She was eighty-two. Her 1954 marriage to the British actor was not a big hit with her father, but it was a big deal for the entertainment media, who kept the Lawfords in their sights as they kept company with the headline names in show business. She and Lawford, who had four children together, were divorced in 1966.

Pat and her sisters worked intimately and tirelessly on their brothers' campaigns through the years while maintaining their own interests in public service. Pat was a noted benefactor of the arts wherever she saw a need, Jean served as ambassador to Ireland under President Clinton, and Eunice was a founder of what is now an international institution, the Special Olympics.

Yet another cancer diagnosis, this one a generation down, startled the family: Kara Kennedy Allen, forty-two, the mother of a young girl and boy, had a cancerous tumor successfully removed from her lung at Brigham and Women's Hospital in Boston in 2003, some thirty years after her brother Teddy lost a leg to the disease.

166

Kara Kennedy Allen, with her father, in 1997.

Taking Sides

Electoral politics was never far from Ted Kennedy's mind, no matter how important other matters were to him and his family. He stood for reelection in 2006, and Republican Ken Chase, like every opponent before him, went down to defeat, drowned in Kennedy votes. In this race, the incumbent took every county, winning by at least 62 percent in each district. But it was on the national stage in 2004 that Kennedy really needed to go to work; his fellow senator from Massachusetts, John Kerry, was the Democratic nominee, and George W. Bush was aiming for a second term in the White House.

The senior senator weighed in on the primary scene early and often for the junior senator. In a speech in a school gymnasium before the caucuses in Iowa, Kennedy amiably chided his audience for not treating him well back in 1980 when they voted for his rival, Jimmy Carter. He was there, though, to put in a good word for Kerry, whose standing in the polls was tottering. Grinning widely, he reminded the assembly: "You voted for my brother. You voted for my other brother. You didn't vote for me!" The crowd broke out in laughter as Kennedy bellowed, "But if you vote for John Kerry, I'll forgive you!"

Kerry won the caucuses by a good margin, and with Kennedy stumping blue-collar and minority voters on his behalf over the primary months that followed, Kerry claimed the nomination, losing to Bush in November in a tight contest.

Hometown salute: Senator Kennedy welcomes delegates to the 2004
Democratic National Convention in Boston.

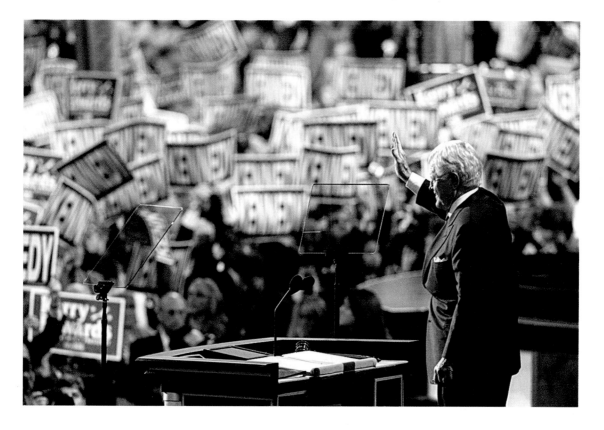

Four years later, in 2008, with Bush ineligible to run and at record lows in

popularity polling, the Democrats staged a fierce battle for their party's nomination,

with Senators Hillary Clinton and Barack Obama playing the leading roles.

Once again Ted Kennedy weighed in early on; with his niece Caroline at his side

in January, he endorsed Obama for the nomination, calling him a man "with

extraordinary gifts of leadership and character."

169

Opposite (Top) Senators Christopher Dodd and Joe Lieberman of Connecticut and their senatorial colleague from Massachusetts keep connected during an inspection tour of New Orleans after Hurricane Katrina, September 2005. (Bottom) Ted gets a warm greeting during a town hall meeting about protecting Social Security, March 2005.
Below (Top) Eunice Shriver and Jean Smith alongside their brother at the dedication of the Rose Fitzgerald Kennedy Greenway in the heart of Boston, July 2004. (Bottom left) A conference with Massachusetts Governor Deval Patrick, April 2008. (Bottom right) The senator reads to young patients at the Boston Medical Center, January 2001.

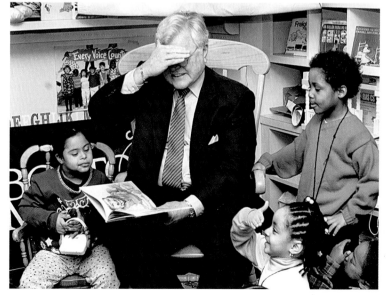

Below Presidential candidate Barack Obama with Caroline Kennedy and Bay State Governor Deval Patrick at his side, acknowledging cheers at a rally at Boston's Seaport World Trade Center, February 2008. Ted Kennedy's endorsement was a significant moment in the campaign of the future president.
Opposite Senator Barack Obama reaches past Senator Ted to shake hands with Congressman Patrick at President Bush's State of the Union speech, January 2007.

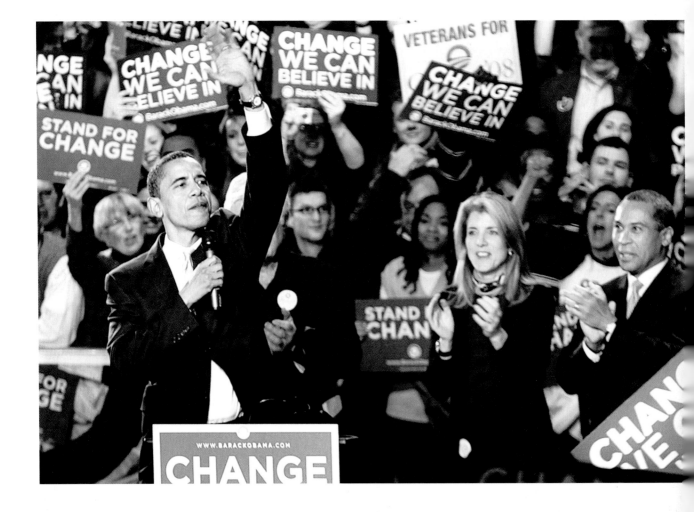

Ever the Statesman

Ted Kennedy at seventy-five seemed invincible. He had survived a plane crash that
killed two others on board, and he had barely escaped with his political life after an
auto accident in which his female passenger died. Invested with uncommon energy,
a spirited joie de vivre, and remarkably good health in spite of a battle with weight
gain, he looked as if he would go on forever. But then, in 2007, came an operation to
clear a blocked carotid artery and, in May 2008, word that he had a malignant brain
tumor of a sort with a low survival rate. After a series of tests, surgeons operated
and afterward set up a regimen of chemotherapy and radiation they hoped would
contain any additional spread of the cancer. Just like that, the senator was off the

campaign trail and facing an uncertain
future. Uncertain to the doctors, that is;
Ted Kennedy knew that he still had things
to attend to.

A bill was pending in Congress that would
shore up Medicare benefits for elderly
citizens, and on first review in the Senate
it had failed by a single vote. In the middle
of his recovery therapy, Kennedy made a
dramatic appearance on the Senate floor
to vote for reconsideration of the bill,

174

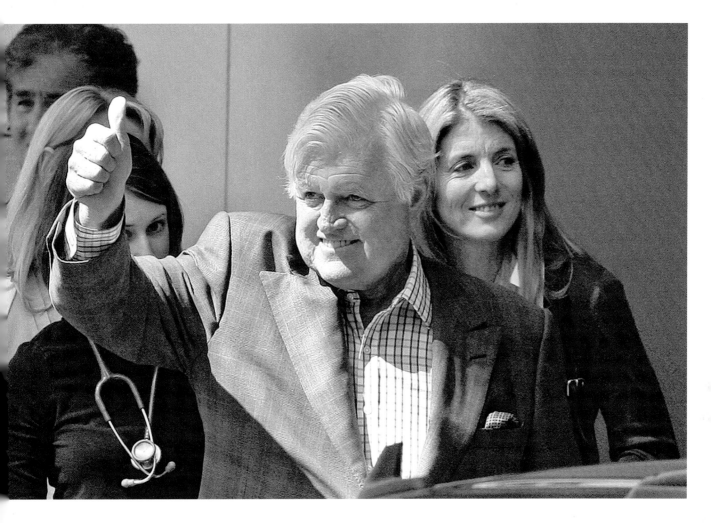

which then passed by a veto-proof margin. The next big event was the Democratic

National Convention, and, again, the senator-patient told his doctor he had matters

to attend to. Stepping gingerly to the podium as the crowd cheered long and loud,

he said, "It is so wonderful to be here. Nothing, nothing was going to keep me away

from this special gathering tonight." The voice was that of the yesteryear Ted

Kennedy as he urged the delegates to continue to validate the timeless values of the

Democratic Party and support what he called "the cause of my life"—health care.

"As I look ahead," he said, "I am strengthened by family and friendship."

It had always been thus for the Lion of the Senate.

Opposite A staff member works the phones at Senator Kennedy's office in Washington after
news of Ted's brain tumor.
Above Days later, the senator gives a thumbs-up as he leaves Massachusetts General Hospital.

Opposite (Top) Delegates cheer the arrival of the ailing Senator Kennedy at the Democratic National Convention in Denver on August 25, 2008. (Bottom) The senator delivers a typical stem-winder of a speech hailing the values of his party.
Below (Left) Patrick Kennedy, Curran Raclin (Vicki's son), Ted Jr., the senator, Kara, and Vicki at Massachusetts General Hospital after the brain tumor diagnosis was confirmed. (Right) Ted applies gusto to his DNC speech.

After the diagnosis, Ted and Vicki retired to Hyannis Port, where the senator always found relaxation. **Below** Walking the dogs at the family compound. **Opposite** To the sea, always to the sea.

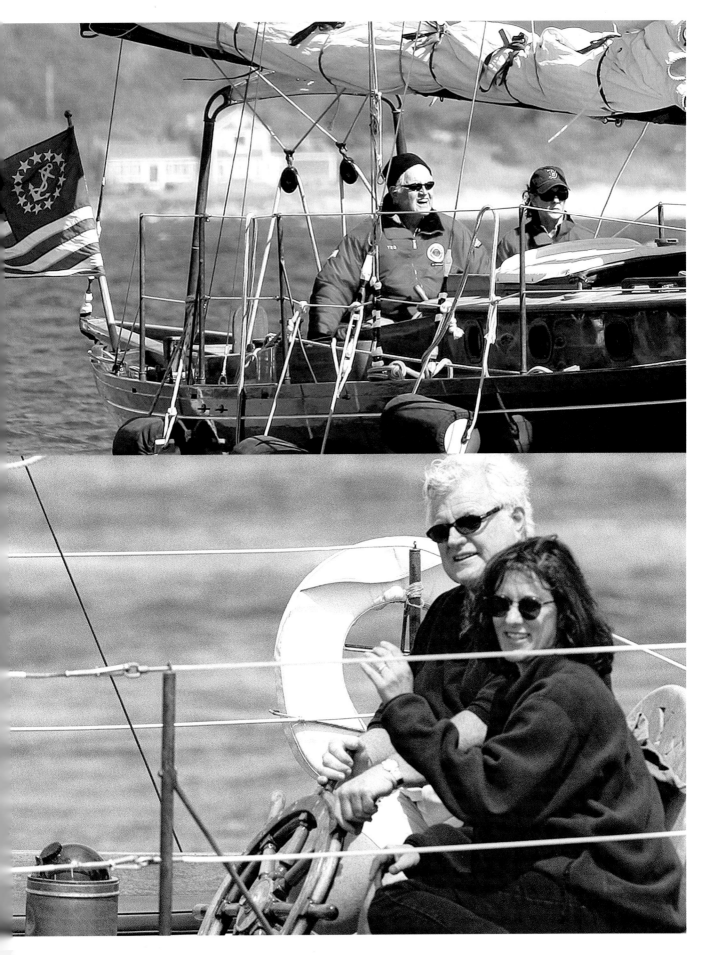

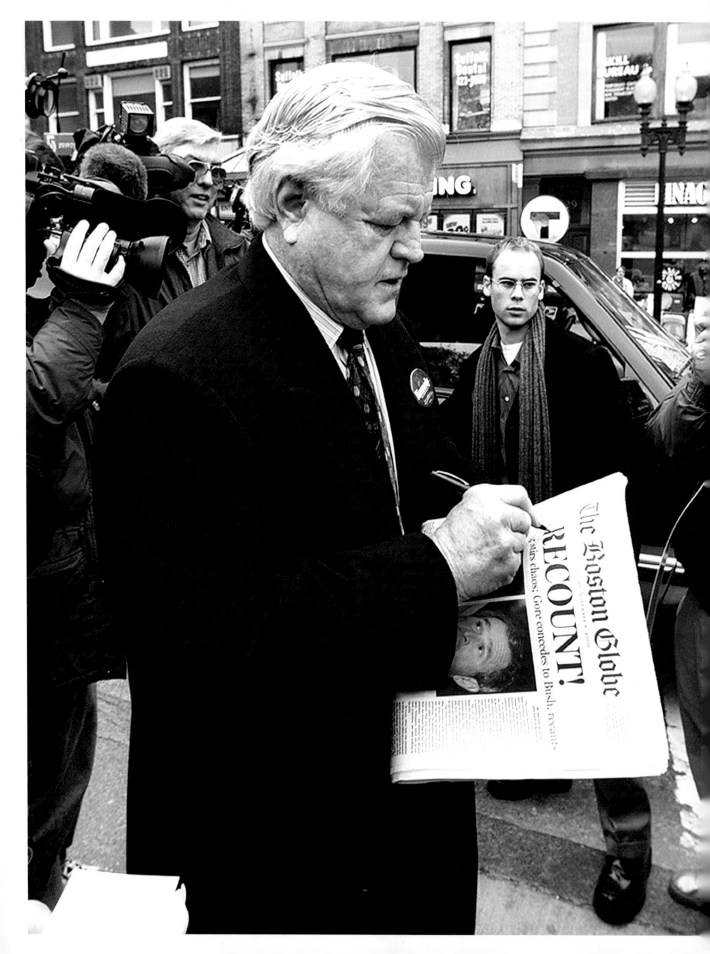

I plan to keep this job until I get the hang of it.

—Ted Kennedy, interviewed in *Time* magazine on July 27, 2003

Fame, Friends, Photo Ops

The morning after: Autographing another winning edition of his
hometown newspaper following reelection in 2000.

Afterword

By Bill Brett

Something news photographers think about more than available light or shutter

speed is access. That's one thing *Boston Globe* photographers have never had to worry

about when it comes to Senator Edward M. Kennedy or his family as they have let us

in to record important moments of their lives and the country's history. But making

a great picture of the senator isn't easy. Despite his relaxed manner in front of even

the most imposing media crush, Ted poses a challenge for those with a camera.

First, the senator is always "on," and always moving. His eyes scan the room and

he regularly strikes up a conversation with those he recognizes. Getting a great

photograph of the senator is more a game of waiting and observing. The young Ted

had a model's good looks, and he photographed well. I think his charm, natural

manner, and accessibility come through in the earliest photos—even when he's

in the shadow of his now larger-than-life brothers. Some might think that as the

senator has aged, he's become an easier subject. Not so. I remember an assignment

with former *Globe* columnist David Nyhan a few months before the Democratic

National Convention in 2004, when I walked around a conference room while the

two talked for an hour, waiting for the one shot that would convey how relaxed Ted

was going into the biggest Boston political event in a long time. That's another

reality photographers get used to: you have to stay at an event for as long as the

senator does, because there's always a chance he'll make news.

Technology has made the job of photojournalism easier for those of us working with digital cameras. In the early part of Ted's life—before I was on the beat—the limitations of the equipment meant photographers often had only one chance at getting the photo that would grace the front page and, we hoped, capture the texture and news of the day. There's a great Paul J. Connell shot of Ted marching in Boston's Evacuation Day parade in 1968. (I remember the event because my brother Jim, who was president of the student council at South Boston High School, marched right along with Ted.) What you can't see is how hard the photographers had to work that day, running backward, carrying all their equipment, scrambling to get a great frame. . . .

Still, I have to say it's a privilege to have photographed the senator—and not just for the front-row seat to history his life has given so many *Globe* photographers. Ted Kennedy knows our end of the business as well as we do. At the conclusion of every press event or one-on-one, he'll inevitably ask, "Did you get the award-winning shot?"

Bill Brett has worked as a photographer and photo editor at the Boston Globe *since 1965.*
Now a freelancer for the newspaper, his latest photography book is Boston, A Year in the Life.

185

Photo Credits

ACKNOWLEDGMENTS

Much of the credit for this book goes to Senator Edward M. Kennedy, who is well known for being generous, gracious, and unwavering in his commitment to freedom of the press. We thank the senator and his family for giving photographers and reporters the access necessary to let all citizens share in their extraordinary lives.

Additional thanks go to Amanda Murray, Simon & Schuster; Lane Zachary and Todd Shuster at Zachary, Shuster, Harmsworth Literary and Entertainment Agency; Colleen Cooney, John F. Kennedy Presidential Library and Museum; Jennifer Quan, John F. Kennedy Library Foundation; the Boston Public Library; Domenic Urdi, freelance imaging; and Jim Munn of Dorian Color, Arlington, Massachusetts.

This book reflects the work of countless talented employees of the *Boston Globe*, past and present. Special thanks to Ann Silvio and Susan Milligan for excerpted interviews; Nancy Buzby, Toby Leith, and Alan Henning for book development support; Jim Wilson, Paula Nelson, Emily Zilm, and the photo department; and all newsroom, imaging, and library staff.

THE BOSTON GLOBE

Jordin Thomas Althaus, 169; Bob Backoff, 50 (bottom right); Max Becherer, 149 (bottom); Pam Berry, 189 (bottom); John Blanding, 124, 190 (left); Bill Brett, 87, 106 (bottom), 113, 114, 152, 171 (bottom left), 195 (top, bottom left, bottom middle); Yoon S. Byun, 176 (top, bottom), 177 (right), 180; Edward F. Carr, 57 (top); Paul J. Connell, front cover, 34, 50 (top right, bottom left), 63 (bottom), 69 (top left), 70, 76, 86 (top right), 98 (top right), 187; Jim Davis, 145 (top left); Bob Dean, ii, 68; Joe Dennehy, 58 (top right), 82 (top, bottom left), 98 (bottom); Charles Dixon, 93; Joyce Dopkeen, 86 (top left, bottom); Ted Dully, 72, 84, 102, 105 (right), 107 (bottom right); Frank Falacci, 28, 58 (top left); Ed Fitzgerald, 199 (top); Bill Greene, 142 (top), 177 (left); Pat Greenhouse, 145 (top right), 171 (top); Stan Grossfeld, 115 (bottom), 189 (middle right); Sam Hammat, 50 (top left); Tom Herde, 165, 194; Ellis Herwig, 88, 94; Frank Hill, 59 (top right); Harry T. Holbrook, 49; Justine Hunt, 172; Edward Jenner, 37, 51; David Kamerman, 179; Edmund Kelly, 56 (top), 58 (bottom left); Yunghi Kim, 145 (bottom); Janet Knott, 106 (top left), 107 (left), 189 (top left, top right, middle left); Suzanne Kreiter, 139, 170 (bottom), 193 (middle); Tom Landers, 105 (left), 119, 141, 163, 182; Matthew J. Lee, 178, 179 (top); Rose Lincoln, 108; Wendy Maeda, 142 (bottom right), 153 (top left), 164, 197 (bottom); Paul Maguire, 63 (top), 65; Sam Massota, 95 (top); Charles McCormick, 38; Michele McDonald, 190 (right); Ollie Noonan Jr., 59 (bottom), 75, 78 (bottom); Frank O'Brien, 77 (top right), 97, 99; Phil Preston, 98 (top left); Joanne Rathe, 118, 133; Evan Richman, 151, 159, 199 (bottom); George Rizer, 106 (top right), 107 (top right), 125, 135, 175; Michael Robinson-Chavez, 142 (bottom left); Stephen Rose, 136, 137 (bottom), 147 (top), 153 (top right), 167, 197 (top right); Joe Runci, 67, 71, 73 (bottom); David L. Ryan, 120 (bottom), 148, 149 (top left), 153 (bottom), 160 (top), 161, 171 (bottom right), 195 (bottom right); William Ryerson, 95 (bottom); Jack Sheehan, 59 (top left); John Tlumacki, 117, 120 (top left, top right), 121, 128, 144 (top), 147 (bottom), 150 (right), 154, 160 (bottom); Lane Turner, back cover, 144 (bottom); Steve Van Meter, 82 (bottom right), 198; Ulrike Welsch, 101; Laurence Welsh, 40; Jonathan Wiggs, 143; Mark Wilson, 137 (top), 173. *Globe* file: 9 (top), 57 (bottom), 58 (bottom right), 77 (top left).

THE NEW YORK TIMES

Keith Meyers, 162; Doug Mills, 191 (right).

AP/ WIDE WORLD PHOTOS

Ed Bailey, 149 (top right); Dennis Cook, 100, 197 (top left); John Duricka, 193 (left); Gretchen Ertl, 192 (left); J. Walter Green, 56 (bottom); Jacob Harris, 43; Paul Sancya, 170 (top); Charles Tasnadi, 123. File: 17, 25 (left), 25 (right), 27, 33, 44, 55, 80, 83, 100, 115 (top), 132, 193 (right), 197 (top middle).

BLOOMBERG NEWS

David Scull, 191 (left), 192 (right).

GETTY IMAGES

Alfred Eisenstædt, 20; Robert Bachrach/Hulton Archive, 13; Hulton Archive, 19, 23, 62, 64, 77 (bottom left); Popperfoto, 77 (bottom right); Herb Scharfman, 78 (top); Grey Villet, 52; Alex Wong, 174.

REUTERS

Bill Powers, 150 (left).

UPI/BETTMAN/CORBIS

Flip Schulke, 79. File: 53, 73 (top), 81, 104.

JOHN F. KENNEDY PRESIDENTIAL LIBRARY

4, 9 (bottom), 10, 11 (top), 11 (bottom), 15 (left), 15 (right), 16 (top), 21 (top), 21 (bottom), 24, 26.

ADDITIONAL PHOTOGRAPHS

© Donal F. Holway/*The Harvard Crimson*, 69 (bottom); Dorothy Wilding © William Hustler and Georgina Hustler/National Portrait Gallery, London, 16 (bottom); *Providence Journal*, 127; *Worcester Telegram & Gazette*, 200.

Picturing Ted

In the rare instances when I was detained or hassled overseas, two words usually helped: Call Kennedy. The senator is a friend of any photojournalist trying to shine a light in a dark place.

But being a Kennedy has its price. I remember Ted appearing at Dorchester High School as a prelude to his unsuccessful 1980 presidential campaign. Shortly before he was scheduled to speak there was a loud bang and then a brief power outage—a false alarm of some sort. The candidate flinched. It was just a fraction of a second but it revealed how fragile we all are, especially Ted. But then he got up and delivered a powerful speech, with his shadow looming large on the auditorium wall.

—Stan Grossfeld, *Globe* staff

I remember an event in October of 1991 at the Kennedy Library, where everyone wanted to know the identity of a striking brunette who was seated up front, intently watching Ted speak.

The other photographers dared me to go up to John Jr., who was in the back of the audience stretching his legs, and ask him about the mystery woman who'd been seated next to him. I took the dare, but of course he brushed me off with a charming smile and the claim that he didn't know her name.

Days later we found out that the woman was Victoria Reggie, Ted's new girlfriend and future wife.

—Pam Berry, former *Globe* staff

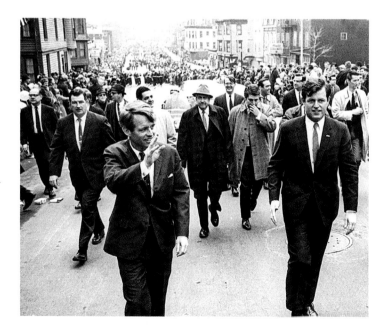

On parade: Bobby and Ted marching on Evacuation Day in South Boston, 1968, as captured by Paul J. Connell.

187

I've photographed Ted Kennedy many times over the years, but one gathering stands out. It was January 1975 and the senator agreed to meet with school busing opponents in his Boston offices. The few photographers who were there were invited into a room, where the atmosphere was about as frigid at the outside temperature, for a brief photo op.

Ted fidgeted in his chair a bit, but I was impressed as he held his composure while being glowered at by Louise Day Hicks, Jimmy Kelly, Pixie Palladino, and other antibusing people, many of whom would build their political careers out of the issue. I remember thinking that we probably wouldn't see Ted march in another St. Patrick's Day parade in South Boston because the locals thought he had abandoned them. But he marched on without flinching, and no matter the year or the circumstances, he still took everyone's calls.

—George Rizer, *Globe* staff

For most of my years covering the Kennedys in Hyannis Port, I stood on the side street or beach of the family compound, armed with the longest of lenses, trying to photograph the family at events such as weddings and Rose's birthdays—until one September day in 1992, when I was welcomed in by the senator himself.

It was not long after he'd married Victoria Reggie. I found myself seated on the carpet in Rose's former living room with fifteen minutes to take exclusive photographs of the couple. Ted was beaming with his new wife close by; they held hands, surrounded by the history of the room. A black-and-white photograph of President Kennedy looked on.

—John Tlumacki, *Globe* staff

At the crack of dawn on November 7, 2006, I headed south from Boston to Cape Cod to photograph Senator Kennedy and Vicki as they voted. It was one of those assignments where public and personal history converged: my father had graduated from Harvard with Ted; I was an affirmative action hire (benefiting from Ted's tireless civil rights work) at the *Boston Globe* in the 1970s, where I was assigned to cover the senator more than once.

On this election day, the political leader emerged from his SUV to greet local well-wishers. Leashless, his dogs led the way before Vicki, all smiles, called the pesky pets back. Then the senator and his wife walked into Barnstable Town Hall for one of those old-home-week votes where the poll workers hugged and kissed him before and after. No surprise, Ted cruised to another reelection.

—Janet Knott, former *Globe* staff

Opposite (Top left and right and middle left) In 2006, the family dogs joined in the excitement of Election Day at Barnstable Town Hall on Cape Cod, where Ted and Vicki got a warm welcome. (Middle right) In 1983, photographers and fans crowded around the politician. (Bottom) Back in October 1991, Vicki was the "unidentified woman" sitting between Ted and John Jr. at Boston's John F. Kennedy Presidential Library and Museum.

Hometown Ted

Senator Kennedy has been a fierce statesman, constantly ahead of his time on some of the biggest issues facing Americans—like health care, education, and minimum wage. At home, he's never lost his reputation as a kind, compassionate, and generous person. Most recently, even as the senator battled for his own health, he was the first person to call me after my knee surgery to make sure that I was doing fine. That's the kind of person he is, never too busy to care for others, and that's also the spirit that he brings to Washington.

—Thomas M. Menino, mayor of Boston (*Boston Globe* interview, October 2008)

In 1986, which was the last year my father (Speaker of the House Tip O'Neill Jr.) was in office, he was determined to obtain federal funds toward the cleanup of Boston Harbor. . . . Senator John Chafee of Rhode Island was the chair of the Subcommittee on Water and it was well known he was no fan of the Boston Harbor cleanup project; in fact, he hated it. . . . Negotiations in conference committee came to a head in the fall of 1986, when the Red Sox were in the playoffs. The Massachusetts delegation would sit in Tip's Capitol Hill office to watch the games and the speaker would dispatch Kennedy down to Chafee's office during the games to 'beat the crap out of him' so that he would include the $100 million in the bill. Kennedy's hard work paid off; Chafee relented and the funding of the cleanup of Boston Harbor was on its way.

—Thomas P. O'Neill III, former lieutenant governor of Massachusetts (*Boston Globe* interview, October 2008)

Above Good times with Tip O'Neill Jr. (left) and Tip O'Neill III (right).
Opposite Bending the ears of Republican senators John McCain (left) and Orrin Hatch (right).

Diplomatic Ted

When we were at Harvard [at the Institute of Politics], every time they'd do something at the Kennedy Library, [Ted] and Vicki would be entertaining and they'd invite me. Somebody would say, "What the hell's Simpson doing here?" And he said, "He's a friend of mine; what the hell's your next question?"
—Alan Simpson, former Republican senator from Wyoming (*Boston Globe* interview, July 2008)

We're like fighting brothers. We're very close as friends, but that doesn't mean we don't fight with each other. I was so pleased when he and Vicki got together. I said to him, "I wrote a song for you and Vicki." ["Souls Along the Way,"] which is on the *Ocean's Twelve* soundtrack. He said, "You did? . . . I want it." I said, "It's the only cassette I have." But I gave it to him. He called me a few days later from the Cape. He said, "Orrin, I just played the song for Vicki. She's on the other end of the boat crying, she loves it so much."
—Orrin Hatch, Republican senator from Utah (*Boston Globe* interview, July 2008)

Even a Republican has to give his due to Ted Kennedy. As governor, when Massachusetts faced a problem which needed help from Washington, I turned to Senator Kennedy and I knew that if anyone could get the job done, it was he. . . . Agree with him or not, he works tirelessly for Massachusetts. And, while he's a die-hard Democrat, he can put politics aside to find common ground with a conservative like me.
—Mitt Romney, former Republican governor of Massachusetts (*Boston Globe* interview, November 2008)

There's one thing you can count on with Ted: he will always keep his word. There are a lot of people in Washington who waver in their commitments, but that's not him.
—John McCain, Republican senator from Arizona (and later presidential nominee) (*Boston Globe* interview, January 5, 2003)

Celebrated Ted

Our friendship goes back a long way. I don't want to remind him of this, but I was dressed in a white shirt and blue pants sitting on the steps of the Democratic side as a page in the Senate about the time that my friend from Massachusetts entered this body. He had years of service with my own father in the Senate. . . .He liked to tease me all the time that he deeply resented the fact that someone would get elected to public office on the basis of their last name.

—Christopher Dodd, Democratic senator from Connecticut (and later presidential candidate) (Senate remarks on February 27, 2002, in observance of Ted Kennedy's seventieth birthday)

He goes where his conscience tells him to go. He hears of children who go through their early years without health care, who come to school unable to learn, and he has made their care his crusade. So millions more children today see a doctor because of Ted Kennedy and millions more will before he is done.

—John F. Kerry, Democratic senator from Massachusetts (and later presidential nominee) (Senate remarks on February 27, 2002, in observance of Ted Kennedy's seventieth birthday)

When my wife and daughter were killed, the first guy there was Ted Kennedy. . . . When some doctors told me my chances of hanging around were not all that good after a couple of aneurysms, he was the guy who took the time to take the train by himself to (my house in) Wilmington, Delaware. . . . He was the first guy to ever come to me when I was down in this place and sat with me when I did not want to be here after six months—Ted Kennedy.

—Joseph Biden, vice president (Senate remarks on February 27, 2002, in observance of Ted Kennedy's seventieth birthday)

Televised Ted

I'm proud to have him represent me in the Senate. I realize that 1991 [which saw confirmation hearings for Supreme Court Justice Clarence Thomas, at which some thought Kennedy was slow in defending Hill] was not his finest moment. I think he really has moved beyond that. I know I have. And I think that the country has as well. But I would say that the country has moved beyond because of people like him. And his willingness to change and to move forward has really influenced what all of us can do and I want to thank him for that.

—Anita Hill, witness in Thomas hearings who alleged sexual harassment; now a professor of social policy, law, and women's studies at Brandeis University in Waltham, Massachusetts (*Boston Globe* interview, August 2008)

That's the ultimate softball question and yet he froze on it because he didn't know why he wanted to be president, except that everybody had wanted him to be president just like they had wanted Jack to be president, the way they wanted Bobby to be president. And that burden is pretty substantial.

—Ellen Goodman, Pulitzer Prize–winning syndicated columnist (*Boston Globe* interview, October 2008)

It was a fairly benign question. . . . "Why do you want to be president?" That was it! That's all I said. "Why do you want to be president?"

—Former network TV correspondent Roger Mudd, who interviewed Ted Kennedy for a CBS special that aired on November 4, 1979 (*Boston Globe* interview, August 2008)

193

Opposite (Left) A seventieth birthday shared with daughter-in-law Kiki Kennedy and grandson Edward M. Kennedy III. (Right) Side by side with Senator (and future Vice President) Joseph Biden.
Above (From left) Eyewitness testimony from Anita Hill, Ellen Goodman, and Roger Mudd.

Star-struck Ted

He is a great fan of Broadway music and Broadway performers, and I have had the rare privilege of joining with the senator and one or two Broadway stars for some impromptu harmonizing after dinner, among friends. Most people know the senator as one of the great statesmen of our time, but I've had the opportunity to sing Cole Porter with him!
 —Keith Lockhart, conductor of the Boston Pops Orchestra (*Boston Globe* interview, October 2008)

In 2004, the hottest Tuesday-night ticket in Boston wasn't a floor pass to the Democratic National Convention, it was a seat at the Symphony Hall tribute to Senator Ted Kennedy. Actress Glenn Close hosted the evening, which included the Boston Pops led by conductor John Williams, Broadway stars Brian Stokes Mitchell and Audra McDonald, and cellist Yo-Yo Ma. The evening's headliner was U2's lead singer, Bono, who informed the media he came for Ted Kennedy: "I wouldn't do it for anyone else."

A Tanglewood appearance of the Boston Symphony Orchestra with James Taylor and Bernadette Peters in 1995 prompted Ted Kennedy to appear on stage and join in on a chorus. At another appearance with Kennedy at Symphony Hall in Boston, Taylor was asked by the *Globe* about the senator's work on arts and culture. "He's a big supporter of the *ahts,*" Taylor said.

Above (Top) Ted as Boston Pops conductor. (Bottom left) Shaking hands with Celtics legend Bill Russell. (Bottom middle) Serenaded by Bono at Boston's Symphony Hall. (Bottom right) With Caroline Kennedy and British Prime Minister Gordon Brown at the John F. Kennedy Presidential Library and Museum.
Opposite Sharing a stage with James Taylor and Bernadette Peters at Tanglewood in western Massachusetts.

Cambridge, Massachusetts, native Ben Affleck has appeared several times with Ted Kennedy and regularly introduces himself as "just a constituent" of the senator. The two worked together in 2004 to secure an increase in the minimum wage, an effort that brought Affleck to Washington, where they appeared together at a press conference at the Capitol. When a woman in the crowd offered Affleck a tour of the building, Kennedy told reporters that he was pouting because he had never received an official tour. Affleck quipped: "That's because they think you were there when they built the Senate."

Actor Martin Sheen has been hitting the campaign trail for the Kennedy family for a few decades now. The actor has lent his voice to support the John F. Kennedy Pesidential Library and Museum in Boston, he has portrayed multiple U.S. presidents, including Kennedy, and he once even wore a costume to ride in the July Fourth parade in Hyannis Port aboard Ethel Kennedy's float. In October 2008, Sheen was stumping for Ted's son Patrick, a Rhode Island congressman, when he told reporters he'd made the trip to the Ocean State because "the Kennedy family has been an inspiration to me all of my adult life."

I admire what Teddy Kennedy does, though I don't agree with his politics. I think he is the best in his field.
—Arnold Schwarzenegger, actor and husband of Kennedy niece Maria Shriver (*Playboy* magazine interview, January 1, 1988)

He's a brilliant actor, but what makes Republicans think he could do well in politics? Of course, it's hard to argue with Arnold when you're hanging upside down by the ankles.
—Ted Kennedy, months before Schwarzenegger was elected governor of California (*Time* magazine, July 27, 2003)

Opposite (Clockwise from top left) Ted enjoying the company of actor Ben Affleck, Pope John XXIII, and comics Lily Tomlin and Bill Cosby.

Playful Ted

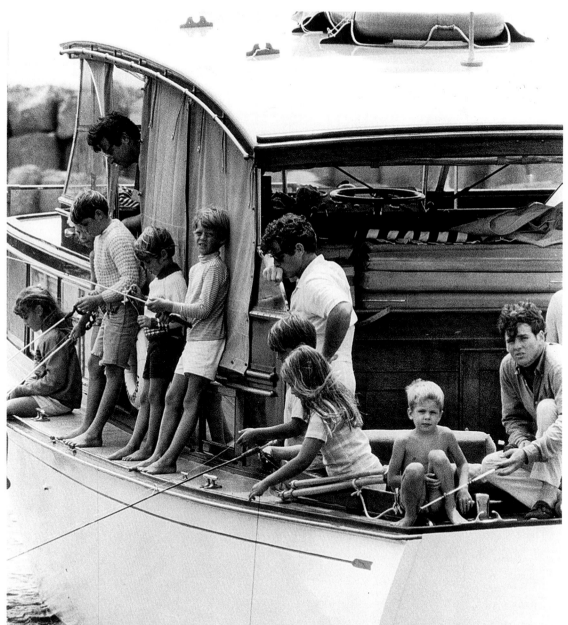

Above Fishing with family on the Cape in 1969.
Opposite (Top) Playing touch football with the media in 1966. (Bottom) Laughing it up with Massachusetts Senate President William F. Bulger at the annual St. Patrick's Day breakfast in 1994.
Overleaf In 1982, Senator Ted sends an airborne message to the loyal Massachusetts voters who reelected him.